THE PRE-RAPHAELITES

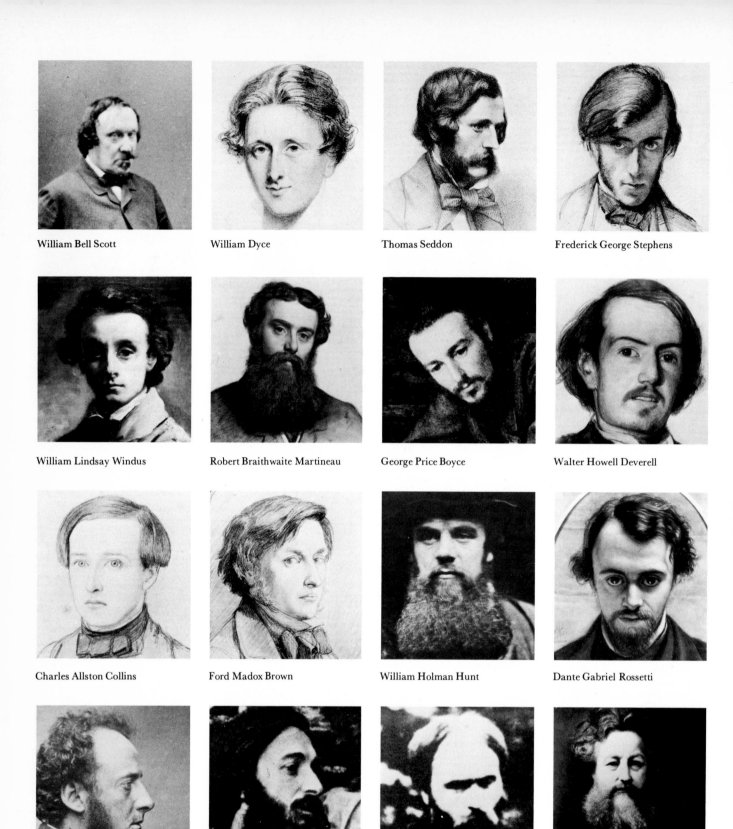

William Bell Scott

William Dyce

Thomas Seddon

Frederick George Stephens

William Lindsay Windus

Robert Braithwaite Martineau

George Price Boyce

Walter Howell Deverell

Charles Allston Collins

Ford Madox Brown

William Holman Hunt

Dante Gabriel Rossetti

John Everett Millais

Arthur Hughes

Edward Burne-Jones

William Morris

THE PRE-RAPHAELITES

JAMES HARDING

RIZZOLI

ACKNOWLEDGEMENTS

We would like to thank all the galleries and institutions who have allowed works in their collections to be reproduced and for providing photographs of the paintings which are illustrated in this book. They are, in alphabetical order: Ashmolean Museum, Oxford; Birmingham Museums and Art Gallery; Christie's, London; Courtauld Institute of Art, London; Trustees of the Faringdon Collection, Buscot Park; Luis A. Ferré Foundation, Museo de Arte de Ponce, Puerto Rico; Fine Art Society, London; Fitzwilliam Museum, Cambridge; Guildhall Art Gallery, London; London Borough of Hammersmith Public Libraries; Johannesburg Art Gallery; Laing Art Gallery, Newcastle-upon-Tyne; Leeds City Art Gallery; Leger Galleries, London; Lady Lever Art Gallery, Port Sunlight; The Makins Collection; City of Manchester Art Galleries; National Gallery of Canada, Ottawa; National Gallery of Scotland; National Gallery of Victoria, Melbourne; National Portrait Gallery, London; Sotheby's Belgravia, London; Tate Gallery, London; Victoria and Albert Museum, London; Walker Art Gallery, Liverpool.

FRONTISPIECE:

All of the following illustrations are details. Left to right in descending order: William Bell Scott (contemporary photograph); *William Dyce* by J. Partridge, 1825, pencil drawing *c.*9½ × 7½ in. (National Portrait Gallery, London); *Thomas Seddon*, lithograph by Vincent Brooks, from *Memoir of Thomas Seddon; Frederick George Stephens* by J. E. Millais, 1853, pencil drawing 8½ × 6 in. (National Portrait Gallery, London); *William Lindsay Windus*, self-portrait, (Walker Art Gallery, Liverpool); *Robert Braithwaite Martineau* by W. Holman Hunt, 1860 (Walker Art Gallery, Liverpool); *George Price Boyce*, detail from a group portrait by H. T. Wells R.A. (ex-collection Mrs Arthur Street); *Walter Howell Deverell* by W. Holman Hunt, 1853 (by courtesy of Birmingham Museums and Art Gallery); *Charles Allston Collins* by J. E. Millais, 1850, (Ashmolean Museum, Oxford); *Ford Madox Brown* by D. G. Rossetti, 1852, pencil drawing 6¾ × 4½ in. (National Portrait Gallery, London); William Holman Hunt, photograph by Wynfield (Anthony D'Offay); *Dante Gabriel Rossetti* by William Holman Hunt, 1853, (by courtesy of Birmingham Museums and Art Gallery); John Everett Millais, photograph by C. L. Dodgson, July 21st, 1865, (collection of Graham Ovenden); Arthur Hughes (contemporary photograph, 1860); Edward Burne-Jones (contemporary photograph); *William Morris* by W. B. Richmond, oil on canvas, 25½ × 19½ in. (National Portrait Gallery, London).

First published in the United States of America in 1977 by

℞IZZOLI INTERNATIONAL PUBLICATIONS, INC.
712 Fifth Avenue/New York 10019

Library of Congress catalog Card number: 77-74338
ISBN: Hardcover 0-8478-0109-8 Paper 0-8478-0108-X

Printed and bound in Great Britain

THE PRE-RAPHAELITE BROTHERHOOD

IN spite of their carefully chosen title, with its implication of a blood bond, the members of the Pre-Raphaelite Brotherhood hardly presented a united front to the world. This is also true of the group of contemporary artists who were drawn into the Movement, with the result that it is difficult to define Pre-Raphaelitism, or to say precisely what constitutes a Pre-Raphaelite painting.

The uniting, in 1848, of the seven men who comprised the membership of the Brotherhood was to have lasting implications for English art. Yet only five of them were painters, and of these, two at least were never to become even remotely competent technically. It is certainly one of the paradoxes of the history of nineteenth century painting that such a small and inadequate missile launched in the face of the artistic establishment should explode with such dramatic effect.

The story of the foundation of the Brotherhood has often been told, beginning with the great rapprochement between Dante Gabriel Rossetti and William Holman Hunt, which developed after Rossetti had seen and admired Holman Hunt's *The Eve of St Agnes*, exhibited at the Academy in the summer of 1848. Next came the introduction of Holman Hunt's friend John Everett Millais into the artistic discussions which took place in the shared studio in Cleveland Place, which Holman Hunt had rented with the money from the sale of *The Eve of St Agnes*. Then came the decision to band together to form a group. The details of these events are well known, but the extraordinary perversity displayed in the choice of the additional members — the suggestion to extend the numbers came from Rossetti — has an enduring fascination.

If there was one English artist who both stylistically and ideologically seems most fitted to have been a member of the Pre-Raphaelite Brotherhood, it was Ford Madox Brown. He was already known to Rossetti, who had become disenchanted with the slow and laborious process of following the course at the Royal Academy Schools. Rossetti had approached Madox Brown, who, after an initial misinterpretation of Rossetti's motives, agreed to take him as a pupil in the early summer of 1848. Rossetti must have recognised in Madox Brown a kindred spirit, and one whose training and artistic experience would have made him of particular value to the newly formed Brotherhood.

Madox Brown's artistic training had been undertaken largely on the Continent. His interest in the early Italian artists had been aroused by his contacts in Rome with the German Nazarene painters who had already successfully established a Brotherhood of artists. As his work at this time embodies many of the precepts that have come to be regarded as peculiarly Pre-Raphaelite, it is curious that Rossetti did not press harder for the acceptance of his suggestion to select Madox Brown to the Brotherhood. In the event this suggestion was vigorously opposed by Holman Hunt, on the grounds that Madox Brown's work was insufficiently free from the artistic conventions of the period, which the Brothers were pledged to oppose — in Holman Hunt's words they meant 'to adopt a style of absolute independence as to art dogma and convention'. It seems possible, however, that Holman Hunt was jealous of Rossetti's earlier enthusiasm for Madox Brown.

It is ironical that Hunt should have successfully opposed the inclusion in the Brotherhood of the man who had such a profound influence on his own work. More bizarre still was the choice of the additional members, for not only had none of them completed a single work which could have given good grounds for choosing them to be Pre-Raphaelites, but one — William Michael Rossetti — was not even an artist. Thomas Woolner, the sculptor, never seems to have attempted a Pre-Raphaelite work and he left England in 1852 to seek his fortune in the Australian gold fields, having failed to attract the sculptural commissions which would have enabled him to make a living.

Apart from these two, the other two members who made up the seven of the original Brotherhood were James Collinson and Frederick George Stephens. James Collinson was the son of a Nottinghamshire bookseller and, at the time of his recruitment to the Brotherhood, a successful Academy student and *genre* painter of modest ambitions. His admission to the Brotherhood was pressed by Rossetti, and though it was opposed by Holman Hunt and Millais on the perfectly correct grounds that he was not 'strong enough for the place', he was none-the-less accepted. F. G. Stephens was then an art student who had not yet completed an exhibitable work, and was early to abandon painting in favour of writing and criticism.

In 1850 Collinson severed his relationship with the Brotherhood for a number of reasons, the stated cause being that he thought membership inconsistent with his obligations as a Roman Catholic. Collinson's dilemma highlights one of the paradoxes of the Pre-Raphaelite Movement — the stated rejection of a religious basis of any kind for the formation of the Brotherhood. This is an almost incredible disclaimer when the subject matter of so many of the Pre-Raphaelite paintings is specifically religious, combined

5

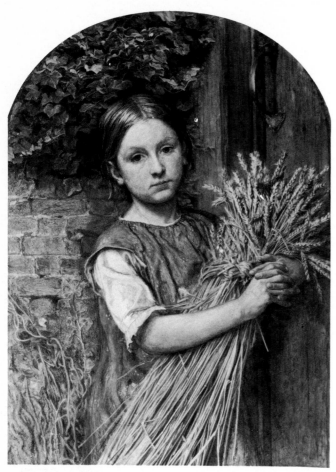

Charles Allston Collins
The Good Harvest of 1854, 1855.
Oil on canvas 17¼ × 13¾ in.
(Victoria and Albert Museum, London)

with the deliberately moralistic tone of much of the rest. The writer Lord Lindsay and the architects A. W. N. Pugin and G. E. Street, all of whom had studied the work and aims of the prototype Brotherhood of the Nazarene painters, were profoundly aware of the close relationship between art and religion which characterised the work of the early Italian painters from whom, like the Nazarenes, the Pre-Raphaelites intended to take their inspiration. Pugin believed their source of inspiration to be specifically Catholic. Yet here, only fourteen years after the publication of *Contrasts*, the work which so unequivocally sets out Pugin's beliefs, we have the most improbable situation in which Catholicism is seen as incompatible with the production of religious works of art. Indeed, Collinson's best known picture and his most 'Pre-Raphaelite' work, *The Renunciation of Queen Elizabeth of Hungary*, celebrates an event in the life of a Catholic saint.

It was proposed that the defection of Collinson be made up by the election of Walter Howell Deverell, an old friend of Rossetti's since his pre-Academy School days when they were both students at Sass's drawing school. Unfortunately, the original enthusiasm for the Brotherhood was already so much diminished that the election never took place. Deverell was, however, amongst the outsiders who joined the Brothers in their most important venture of 1850, namely the planning and publication of their magazine, *The Germ*.

William Michael Rossetti naturally welcomed the idea of

this literary venture as it allowed him to make his own creative contribution to Pre-Raphaelitism, his involvement until then having been merely suggestions made at meetings. His most valuable contribution to the movement was indeed to be literary. His writings on the Pre-Raphaelite Movement and on his brother in particular, shine out from the mass of biographical and autobiographical material published about these artists.

The first preparations for assembling the material for *The Germ* were made in the late autumn of 1849 and the first number duly appeared in the early part of the following year. Although only four issues of the magazine were published they are important in that they contain the only attempts at a statement of aims ever put together by the Brotherhood, who had embarked on their revolutionary course two years earlier without issuing the customary manifesto. Possibly this was because neither at that stage nor at any later time in their brief period of unity could they truly be said to have a common artistic purpose. *The Germ* thus served to give the Brotherhood a recognisable identity. Arthur Hughes claimed that he was converted to Pre-Raphaelitism by reading it. It also increased the number of adherents (though not the actual number of Brothers since no further members were elected after the original seven) through invitations to contribute to the magazine. These included — predictably — Christina Rossetti, whose poetry was to inspire some of the finest Pre-Raphaelite illustrations, Coventry Patmore, the poet, who had introduced some of the Brothers to Tennyson the year before, and whose great work *The Angel in the House* might be described as a Pre-Raphaelite poem, and William Bell Scott, the poet and artist, who but for his age (he was ten years older than Madox Brown) and his situation — he held a post in the Government School of Design in Newcastle from 1844 to 1864, would surely have been much more closely associated with the Movement. A close parallel between his work and that of Madox Brown is apparent in *Iron and Coal* (c.1855–60), which must have been influenced by *Work* (1852–63). Similarly, *Albrecht Dürer of Nuremburg* is Brown-like in both subject and composition. Madox Brown also contributed to *The Germ*, both with articles and illustrations. At this date — the early part of 1850 — it still required a considerable act of faith to join the Pre-Raphaelites. Their corporate image had received nothing in the way of encouragement either from the critics or from the public.

Earlier — in 1848 — with the members of the Brotherhood chosen, Rossetti, Millais and Holman Hunt had launched out into their first Pre-Raphaelite venture: Millais with *Lorenzo and Isabella*, a subject taken from Keat's poem *Isabella*, Holman Hunt with an episode taken from Bulwer Lytton's novel *Rienzi*, and Rossetti with *The Girlhood of Mary*. At this stage the existence of the Brotherhood was still a well-kept secret, and all three received complimentary notices when they were exhibited in 1849, *Isabella* and *Rienzi* at the Academy, and Rossetti's picture at the Free Exhibition — an annual event which took place just before the yearly Academy exhibition. All three pictures were sold, and Millais assumed (with some justification) that 'the success of the P.R.B. is now *quite certain*'. It was thus with some incredulity that they were to see the crushing of their hopes in the following year. The secret of the initials P.R.B. which had followed the signatures on the pictures exhibited in 1849 was now out, and this seemed to arouse the ire of the press. *The*

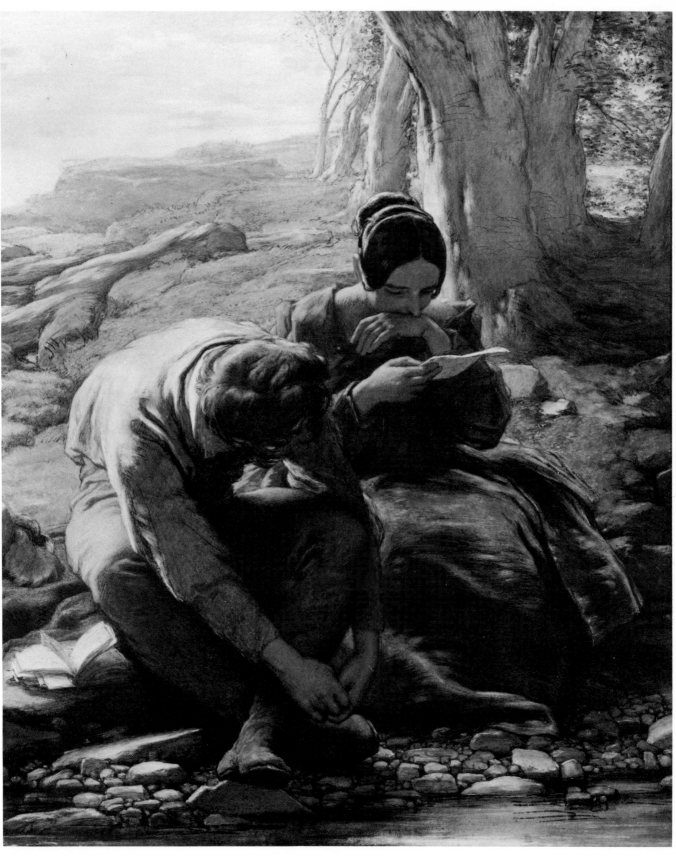

William Mulready
The Sonnet, 1839. Oil on panel 14 × 12 in.
(Victoria and Albert Museum, London)

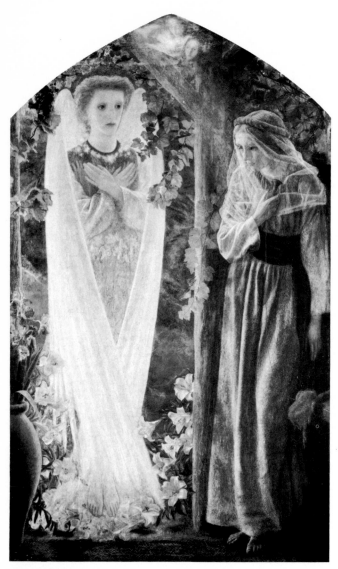

Arthur Hughes
The Annunciation, 1858.
Oil on canvas 22⅜ × 13¼ in.
(By courtesy of Birmingham Museums and Art Gallery)

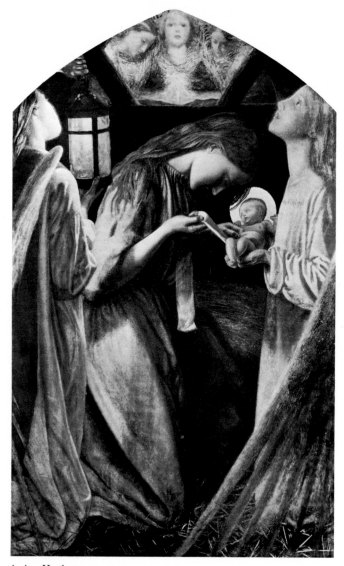

Arthur Hughes
The Nativity, 1858.
Oil on canvas 22⅜ × 13¼ in.
(By courtesy of Birmingham Museums and Art Gallery)

Times wrote of Millais' new Academy exhibit, *Christ in the House of his Parents*, that 'this picture is plainly revolting', and Holman Hunt's *A Converted British Family Sheltering a Christian Priest from the Persecution of the Druids* was stigmatized for its 'uncouthness'.

Similarly, both Rossetti's *Ecce Ancilla Domini* and Walter Deverell's *Twelfth Night* had already received unfavourable notices at the Free Exhibition which had opened earlier. This blow, coupled with the vicious attacks on his Brotherhood friends, struck Rossetti particularly hard after his endless and mainly unsuccessful struggles with the recalcitrant perspective of this picture, and made him decide not to exhibit his work again. He seems to have become disenchanted with Pre-Raphaelitism at the same time since he attempted only one more picture which adheres to strict Pre-Raphaelite principles — the ill-fated *Found* which caused him endless trouble and despair, begun in 1854 and never completed. His later 'open-air' composition, *Writing in the Sand*, was painted in a studio, and he borrowed two watercolours from G. P. Boyce to use as a model for the background. From 1850 until the early 1860s his output was to be dominated by the mediaevalising pattern-making of the *St George* works and literary bias of the *Dante* subjects.

Although appalled by the vicious attacks on their work, neither Millais nor Holman Hunt were deflected from their course and in the following year continued to develop on the lines indicated by the earlier works. Both completed three pictures whose subject matter neatly encompasses the principal preoccupations of the Movement. Millais' *Mariana*, a Tennysonian subject, treats a literary theme in a totally painterly fashion, reinforcing the mediaevalism of the text not only with carefully chosen accessories, but also through the rich colouring reminiscent of that found in stained glass or illuminated manuscripts. Similarly in Holman Hunt's two Shakespearean subjects, *Claudio and Isabella* and *Valentine rescuing Sylvia from Proteus*, the artist uses colour to heighten the emotional intensity of the scene. Millais' *The Return of the Dove to the Ark* treats a biblical subject with the same insistence on realism and absence of mysticism which had already shocked the critics in *Christ in the House of His Parents*

John Brett
Florence from Bellosguardo, 1863. Oil on canvas 23⅝ × 39⅞ in.
(The Tate Gallery, London)

and Rossetti's *The Girlhood of Mary*, and which was to remain a characteristic of Pre-Raphaelite painting.

The third picture completed by Millais in 1851, *The Woodman's Daughter* (which we now see distorted by later re-working) although ostensibly a literary subject taken from a poem by Coventry Patmore, seems to fit more into the important category of social comment or moralising. This was an aspect of painting which preoccupied all the Pre-Raphaelites from this date, particularly Holman Hunt, a number of the subjects probably being suggested by the publication, in 1851, of Henry Mayhew's *London Labour and the London Poor*. It is in this type of picture where the Victorianism of the Pre-Raphaelites is most apparent, since these works are the ideological heirs of pictures like *Train up the Child* by Daniel Maclise (which is very like *The Woodman's Daughter* in its symbolic content, the pose and gesture of the rich child in each case being remarkably similar), or *The Sonnet* by William Mulready, which is closely related to the large group of Pre-Raphaelite 'wooing' pictures. Here the pose is close to that used by Holman Hunt in *The Hireling Shepherd*, the third picture to be completed in 1851/2. The best known of these moralising pictures is probably *The Awakening Conscience*, painted in 1852, which, with its painstaking build-up of significant detail, comes perilously near to being a highly finished Victorian narrative painting.

Apart from these three types of painting (namely biblical, moralising and mediaeval literary themes), two further categories are treated sufficiently often to constitute a characteristic Pre-Raphaelite subject. Firstly, the microscopically observed portrait, which in its unflattering vision

differs completely from the currently fashionable society portraits, such as those of Winterhalter or Richard Buckner. Furthermore, very few of the pictures of family friends or patrons painted in the 1850s by the Pre-Raphaelites are entirely without literary or moral references.

Secondly, there is the Pre-Raphaelite or Ruskinian landscape painting, an area of activity of great importance to the Movement and of considerable significance to British art of the period, but apparently of total irrelevance to the development of modern painting. It is instructive to remember that John Brett's *Val d'Aosta* was painted only five years before the first Impressionist pictures were shown at the *Salon des Refusés* in 1863. Brett was actually a year younger than Pissarro and Hughes was born in the same year as Manet. Like portraiture (with the exception of Holman Hunt's pictures from his first journey to the East in 1854/5), pure landscape was rare in the earlier Pre-Raphaelite work but several later adherents of the Movement were primarily landscape painters, notably Thomas Seddon, Brett, J. W. Inchbold and Rossetti's friend and patron G. P. Boyce. All the outdoor pictures have passages of minutely observed landscape in them, each blade of grass assuming the same significance as each pane of stained glass in the interiors, and in spite of the moralising subject matter a picture like *Our English Coasts (Strayed Sheep)* was chiefly influential as a landscape painting.

In 1851 Millais and Holman Hunt again exhibited at the Royal Academy the pictures which they had been working on since the previous year (*The Woodman's Daughter, Mariana, The Return of the Dove to the Ark* and *Valentine rescuing Sylvia from*

9

Proteus). Madox Brown sent in his *Chaucer at the Court of Edward III*, following it in 1852 with *Jesus Washing Peter's Feet* and *The Pretty Baa-Lambs*, an ambitious landscape painted under considerable difficulties in full sunlight. After 1853 he ceased to exhibit at the Academy as he felt the hanging arrangements were too unsatisfactory. Charles Allston Collins followed his earlier picture of *Berengaria's Alarm for the safety of her husband Richard Coeur de Lion, awakened by the sight of his girdle offered for sale at Rome* (also known as *The Pedlar*) exhibited at the Academy in the previous year, with *Convent Thoughts*, a rather unsatisfactory and derivative picture which is none-the-less important in being the subject of the same anti-Catholic sentiments which had been aroused earlier by Rossetti *(Ecce Ancilla Domini)* and Millais *(Christ in the House of his Parents)* and is thus identified with the Movement through shared odium. Again the reaction from the critics was extremely discouraging, and it was to be little better in the following year even though the Pre-Raphaelites had in the meantime acquired the support of an important champion.

Despite the confidence in themselves and their artistic ideals which this spate of creative activity implies, and their willingness to face the hostile critical reception, the members of the Brotherhood can have felt nothing but relief when they received the support of the most eminent and influential art critic of the period. At this point John Ruskin was persuaded by Coventry Patmore to write to *The Times*, taking issue with the critics over the Pre-Raphaelite pictures. His letter, and the two following ones which raised further points, with their qualified but sincere praise for the work of Millais and Holman Hunt, caused the P.R.B. work to be viewed in a new light. Ruskin is now almost entirely ignored and his works unread, but his reputation in his own time was regarded as unassailable, and his influence was correspondingly great.

In 1851 at the time of the publication of the first letter in *The Times* Ruskin — as he was at considerable pains to point out — did not know any of the Pre-Raphaelite artists personally, but he was to get on terms of friendship with Rossetti (whose faithful patron he became) and Millais. His relationship with Millais ended inevitably when his marriage was annulled and his wife married the artist, but during the period of their intimate friendship Ruskin managed to interest Millais in a number of his antiquarian, architectural and geological enthusiasms. His influence on Millais' painting was considerable, and it is arguable that the decline in the poetic quality of Millais' work, which can be dated approximately from the time of his marriage, was due partly to the withdrawal of Ruskin's valuable counsel. The blame for this decline has also been attributed to his wife. Obviously the need to provide for a growing family forced a more popular and technically less demanding style on him, but it has also been said of her that had she remained married to Ruskin he would have written *Bubbles* (probably Millais' best known picture, and arguably his worst!), suggesting

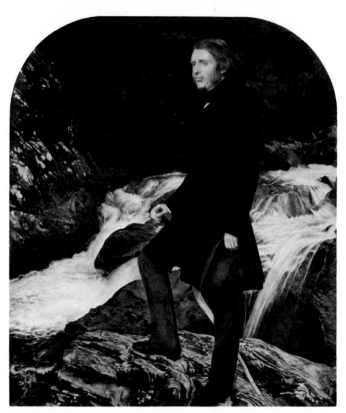

John Everett Millais
John Ruskin, 1853–4.
Oil on canvas 31 × 26¾ in.
(Christie's, London)

that her insidiously trivialising influence was irresistible.

During the following three years critical reception of the Pre-Raphaelite exhibits at the Academy was, predictably, inclined to be favourable. In 1856 Ruskin was able to write in his *Academy Notes:-* 'animosity has changed into emulation, astonishment into sympathy, and . . . a true and consistent school of art is at last established in the Royal Academy of England'. This happy outcome to the early struggles had already been established by the enthusiastic reception by the French public of the Pre-Raphaelite pictures sent to the Exposition Universelle in Paris in the previous year. These included the previously reviled *Chaucer at the Court of Edward III* by Madox Brown, as well as *Our English Coasts (Strayed Sheep)* and *The Light of the World* by Holman Hunt and three pictures by Millais, *The Return of the Dove to the Ark*, *Ophelia*, and *The Order of Release*. The supreme irony was that by now the Brotherhood had been abandoned. Rossetti wrote in January 1854, when Holman Hunt had left for the East only two months after Millais had been elected as Associate of the Royal Academy:- 'now the whole round table is dissolved'. But if the days of the Brotherhood were over, Pre-Raphaelitism was by no means dead.

PRE-RAPHAELITISM

Millais was still to paint at least two Pre-Raphaelite pictures. *The Blind Girl,* one of his finest works, was exhibited at the Academy in 1856, and the controversial and unsatisfactory *A Dream of the Past: Sir Isumbras at the Ford,* in 1857. Holman Hunt continued to adhere to Pre-Raphaelite precepts throughout his life, and some of his most symbolically complex and highly wrought pictures were still to come, though he was never to match the poetic quality of *Claudio and Isabella.* The texture of his later works is unpleasant, which is probably the result of his overworking of the detail. In spite of the fact that he had abandoned Pre-Raphaelitism in its narrowest sense in 1850, Rossetti established his own aspect of the Movement which was to influence the work of two of the best known of the later adherents — Edward Burne-Jones, whose early Pre-Raphaelite pictures are modelled on the literary and mediaevalising aspects of Rossetti's work, and William Morris. Both of them decided to leave Oxford in 1856 and make their careers in art after seeing the work of the Pre-Raphaelites. Arthur Hughes painted his series of pastoral pictures of lovers — *April Love, The Long Engagement,* and *The Tryst* in the mid and late 1850s, and worked on *Home from Sea* until 1863. Madox Brown did not complete *Work* until 1865; *The Hayfield* (one of his most beautiful pictures) and *Stages of Cruelty* — a rather unsatisfactory picture which he reworked later, but undeniably a Pre-Raphaelite subject — were painted in 1855 and 1856.

In 1857 a joint project was undertaken by Rossetti, Hughes, Burne-Jones and William Morris, with the help of three other friends of Rossetti's — Valentine Prinsep, J. Hungerford Pollen and Spencer Stanhope. This was the decoration of the new Debating Hall (now the library) of the Union Building in Oxford. Only one member of this group had any previous experience of mural painting. J. Hungerford Pollen, a fellow of Merton College and an amateur artist had decorated the roof of Merton College chapel in 1850. In 1852 his conversion to Catholicism lost him the Merton Fellowship, and he then became a professional artist, collaborating a number of times with Benjamin Woodward, the architect of the Union Building, who was instrumental in securing the commission of the fresco decoration for Rossetti and his friends. Lack of technical knowledge led to a rapid deterioration of the decorations, and it is now hard to judge their significance to the movement.

A further joint venture, the founding of the decorating firm of Morris, Marshall, Faulkner and Co. in 1861, which involved Burne-Jones, Rossetti and Madox Brown, as well as Morris himself, was to prolong the life of the Pre-Raphaelite movement in certain of its aspects until after the turn of the century. Morris and Burne-Jones were both to gather adherents throughout their careers, notably in Birmingham where the group based on the School of Art can be seen as late Pre-Raphaelites, but Morris's influence was mainly in the field of decorative art, when the powerful impact of the early P.R.B. paintings (which had attracted many imitators) had long since evaporated.

By 1857 Ruskin's earlier admiration for Millais had perforce undergone a drastic reappraisal, and his severe criticism of *A Dream of the Past: Sir Isumbras at the Ford,* exhibited at the Royal Academy in that year, might be taken as a death knell for Pre-Raphaelitism. Even if the death throes were fairly prolonged, the inevitable end was never in any doubt. At the time of the Exposition Universelle in Paris the French critic Theophile Gautier had written predicting that the Pre-Raphaelites would create a school in England, but he doubted if they would be imitated in France as their methods were too demanding. He was, of course, right but he failed to predict the important influence of the style rather than the technique. A school of painting which aspired to Pre-Raphaelitism had indeed already been created in England — Ruskin speaks of these imitators in his lecture on the Pre-Raphaelites in 1853 — though not all the works which were clearly influenced by the Pre-Raphaelite painters actually fulfilled the conditions necessary to make them into true Pre-Raphaelite pictures. The diversity of styles, the lack of coherent aims beyond the vague undertaking to go back to the purity of concept and execution of early Italian painting, and the disparity in technical ability found in the work of the members of the Brotherhood all make it hard to codify the exact requirements for such a painting. Once it is admitted that Pre-Raphaelite painters existed outside the original Brotherhood and their circle of associates, then the field of Victorian painting presents a rich choice, and the opportunity to expand the group has often been seized upon with enthusiasm.

It is not unusual to find the works of Burne-Jones' maturity described as Pre-Raphaelite. Rossetti's last works, which are quite different in character from his few Pre-Raphaelite paintings, are similarly described but lack the intensity of poetic vision and suffer from the cramped perspective which characterises the mediaeval and Arthurian subjects which were his personal contribution to Pre-Raphaelitism. But these at least are the work of an accepted Pre-Raphaelite. Collinson was so briefly a member of the Brotherhood that Pre-Raphaelite influence on his work

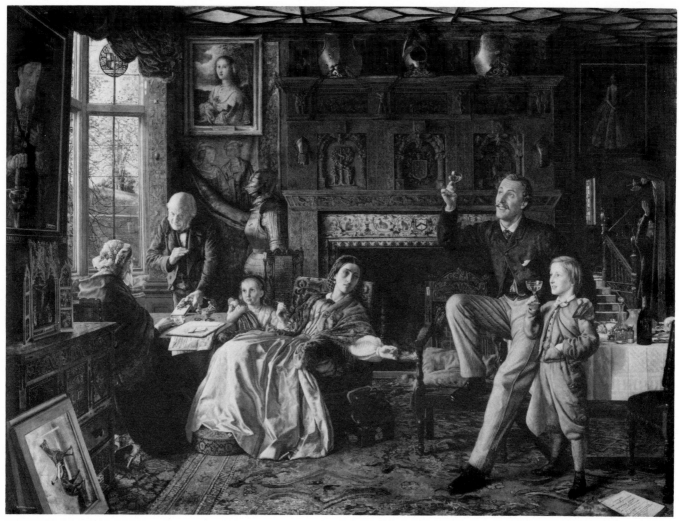

Robert Braithwaite Martineau
The Last Day in the Old Home, 1862. Oil on canvas 42¼ × 57 in.
(The Tate Gallery, London)

was slight, and most of his pictures are in the *genre* style that he had adopted as a student.

The real difficulties emerge when dealing with the work of other painters who are profoundly influenced by the Pre-Raphaelites, while not actually managing to produce Pre-Raphaelite pictures. Robert Braithwaite Martineau is an instructive example. From 1851 to *c.* 1865 he was closely associated with Holman Hunt, first as a pupil and then through sharing a studio with him. His *Kit's Writing Lesson*, which was exhibited at the Academy in 1852 was painted under Holman Hunt's supervision, but remains simply a narrative picture with an exceptionally meticulous finish. Martineau's best known work, *The Last Day in the Old Home*, (which he himself regarded as his masterpiece) is a supreme example of the Victorian model in which 'every picture tells a story' and is clearly a direct ancestor of the famous 'problem' pictures of W. Q. Orchardson and the Hon. John Collier.

A number of individual works by artists who either painted very little, or were very briefly influenced by the Pre-Raphaelites, have been added to the canon for want of a suitable alternative category in which to place them. P. W. Calderon's *Broken Vows* is clearly reminiscent of Millais, particularly in the much-used device of the wall dividing the

picture-plane, as in *The Huguenot*, which with *Waiting*, also by Millais, provide the closest parallels to Calderon's picture. Others who came into this category of artists influenced specifically by Millais are W. L. Windus, James Campbell (his picture of *The Poacher's Wife* has the same woodland setting as *The Woodman's Daughter* and an unfinished picture of the same subject started by Millais in 1860 is now in the Birmingham Art Gallery) and W. Shakespeare Burton.

Other so-called Pre-Raphaelite works are those inspired by the work of Rossetti, the most important artist in this group being Frederick Sandys, whose *Morgan Le Fay* is a dramatic and successful exercise in Rossetti's mediaeval fantasy style. The difference between a true Pre-Raphaelite picture and one which merely observes certain rules of composition and execution is most clearly shown by comparing two superficially not dissimilar works, Deverell's *A Pet* and John Brett's *Lady with a Dove*. The latter, which was painted in 1864, is, like *Kit's Writing Lesson*, merely a portrait with a highly detailed finish, whereas in *A Pet* the garden at Kew where it was painted is given as much tonal emphasis as the figure, and is of nearly equal importance to the composition.

As can be seen from the above account most of the fringe

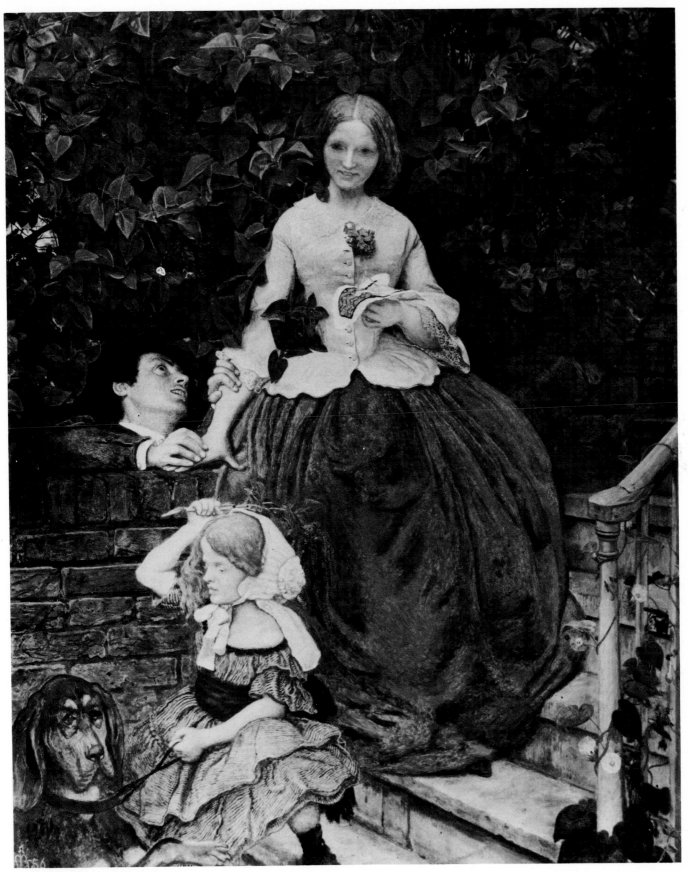

Ford Madox Brown
Stages of Cruelty, 1856–90. Oil on canvas 24½ × 23 in.
(City of Manchester Art Galleries)

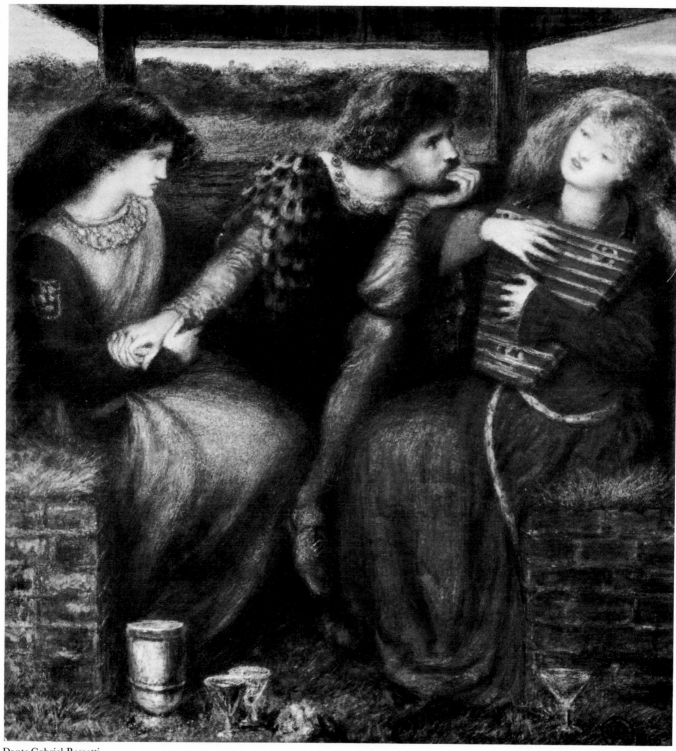

Dante Gabriel Rossetti
The Merciless Lady, 1865. Watercolour 12¼ × 12⅜ in.
(Courtesy of the Fine Art Society Ltd., London)

members of the Pre-Raphaelite movement, with the exception of William Bell Scott and Madox Brown, were near contemporaries of the original members of the Brotherhood. William Dyce, an artist whose claim to be connected with the movement is undeniable, was their senior by over twenty years and an established Edinburgh portrait painter long before he had any contact with Pre-Raphaelitism. He had anticipated by some years the P.R.B. interest in early Italian Art, and like Madox Brown, had had contacts with the German Nazarene painters when he was in Rome in the 1820s. He was a pioneer in the revival of fresco painting, and at the time of the foundation of the P.R.B., was engaged on the monumental project of decorating the Queen's newly built house, Osborne, on the Isle of Wight. His early work includes a number of pictures inspired by early Italian painting, with recognisable overtones of Nazarene influence,

but he is clearly at this period a 'Raphaelite' pure and simple, the parallel being particularly marked in the early *Madonna and Child* (1827) now in the Tate Gallery. He repeated this subject — still in a very Raphaelesque vein — for Prince Albert in 1845. *Jacob and Rachel* (1853) is an interesting example of a Raphael composition being gradually turned into a Pre-Raphaelite picture. The pictures which are usually identified as his Pre-Raphaelite works are *George Herbert at Bemerton* (1861), the rather unsatisfactory *Titian's First Essay in Colour* (1856/7) which looks as if it were little Lord Fauntleroy rifling the old Earl's flower-beds, and *Pegwell Bay* (1859). So minutely observed were the details in this remarkable work that Dyce was accused of using a photograph to work from. This he categorically denied, but there seems to be no question that the picture was influenced by photography. The figures have the air of being captured in a blink of the eye, momentarily transfixed, rather than contemplated in still poses.

The advent of photography was to have far-reaching consequences for painting. Millais, for example, used photographs specially taken by Beatrix Potter's father to fix and maintain the poses in his pictures. Had this accusation been levelled at Dyce later when Corot's and Degas' experiments using photography to aid composition had been widely discussed, he might not have felt the need to repudiate his debt to photography so unequivocally.

The result of any serious attempt to define the meaning of Pre-Raphaelitism is, of course, to refine the category. The pictures painted by the original members of the Brotherhood and their close associates between the end of 1848 and 1856 form the nucleus from which further definitions can be made. On this basis it can be seen that both Millais and Hughes were painting historical or narrative pictures by the end of the 1850s, and in the early 1860s Rossetti began to concentrate on the romantic figure subjects which dominate his later work. Although Madox Brown continued to use the curious boxed-in composition which is a characteristic of both his and Rossetti's Pre-Raphaelite work, his later pictures move away from Pre-Raphaelitism from the 1860s onwards, partly no doubt because the necessity of producing what he called 'domestic pot-boilers' to keep the family fed made the labour of completing a highly finished picture too great.

In this context of diminishing P.R.B. solidarity, it is with some surprise that one learns of the plans inspired by the Pre-Raphaelite exhibition at Russell Place organised by Madox Brown, to form an exhibiting society for the group. The short-lived (1858–61) Hogarth Club's main function seems to have been to confer Pre-Raphaelite status on a number of contemporary artists, some of them Liverpool School landscape painters like William Lindsay Windus, William Davis, Alfred William Hunt and Daniel Williamson. The fact that even with this injection of new enthusiasm

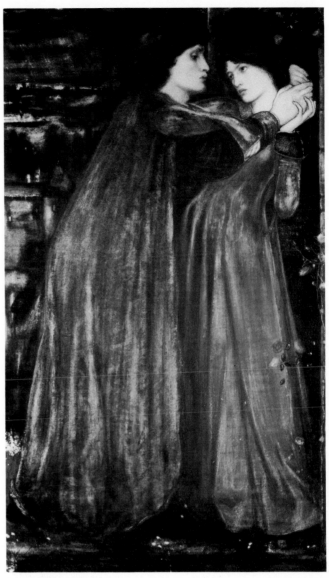

Edward Burne-Jones
Clerk Saunders, 1861.
Watercolour 27 × 16½ in.
(The Tate Gallery, London)

the Club did not survive beyond the early 1860s confirms once again the inescapable truth, that but for a very few belated Rossettian essays by Burne-Jones and the dogged adherence to his P.R.B. precepts on the part of Holman Hunt, the Pre-Raphaelite Movement was finished by 1860. It is a measure of the importance of P.R.B. ideas that a mere decade of artistic activity could have such a profound effect on a century of intensely prolific production.

LIST OF COLOUR PLATES

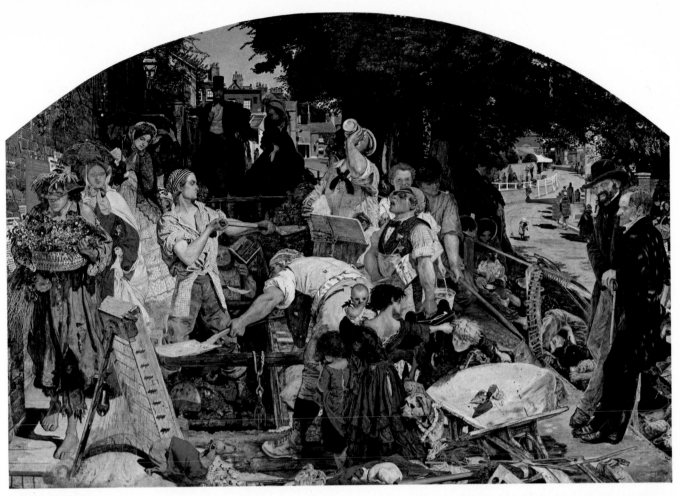

Ford Madox Brown

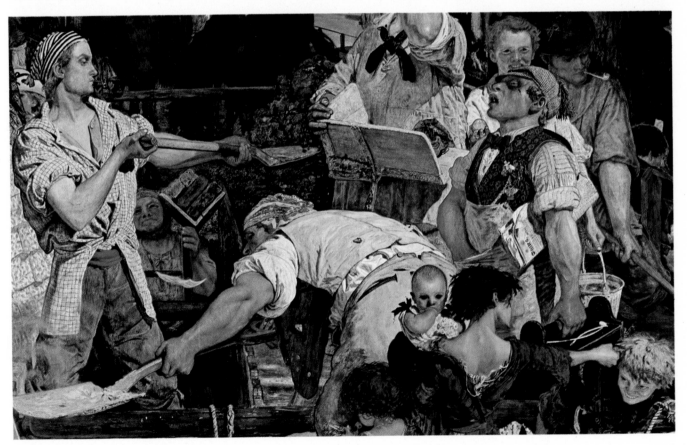

Ford Madox Brown

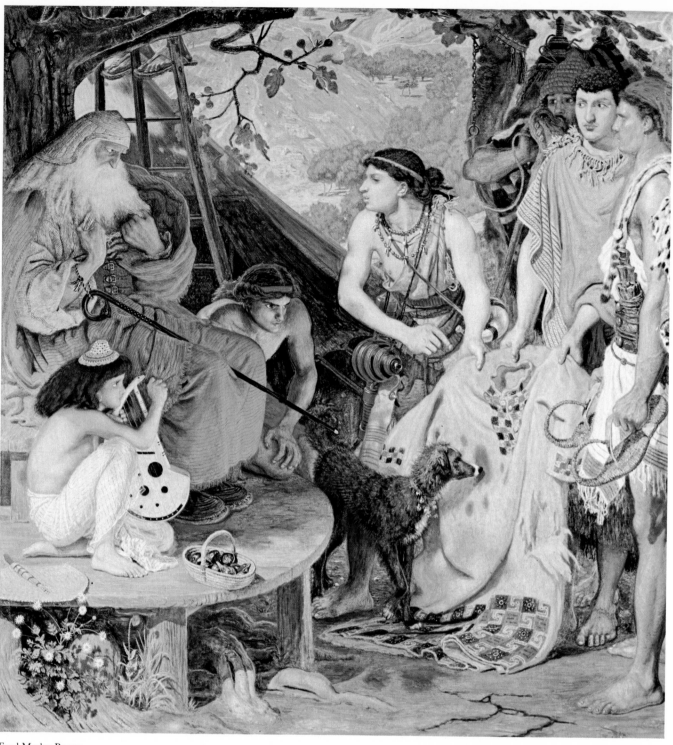

Ford Madox Brown

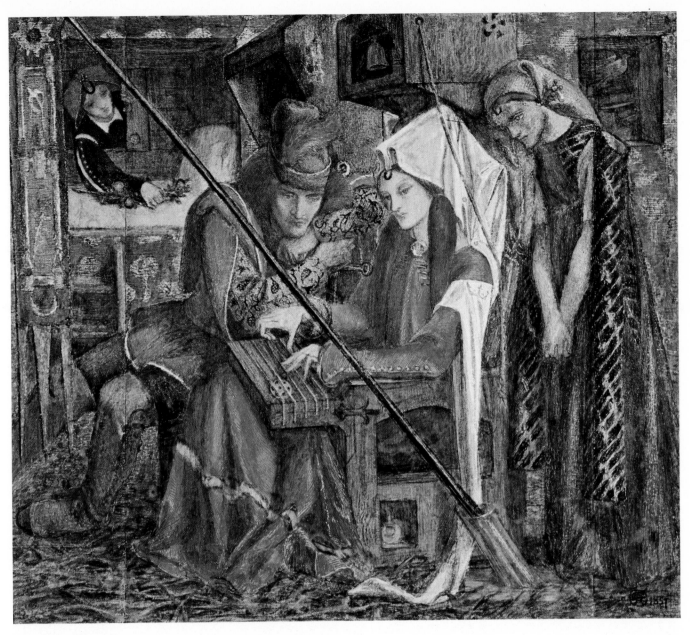

Dante Gabriel Rossetti

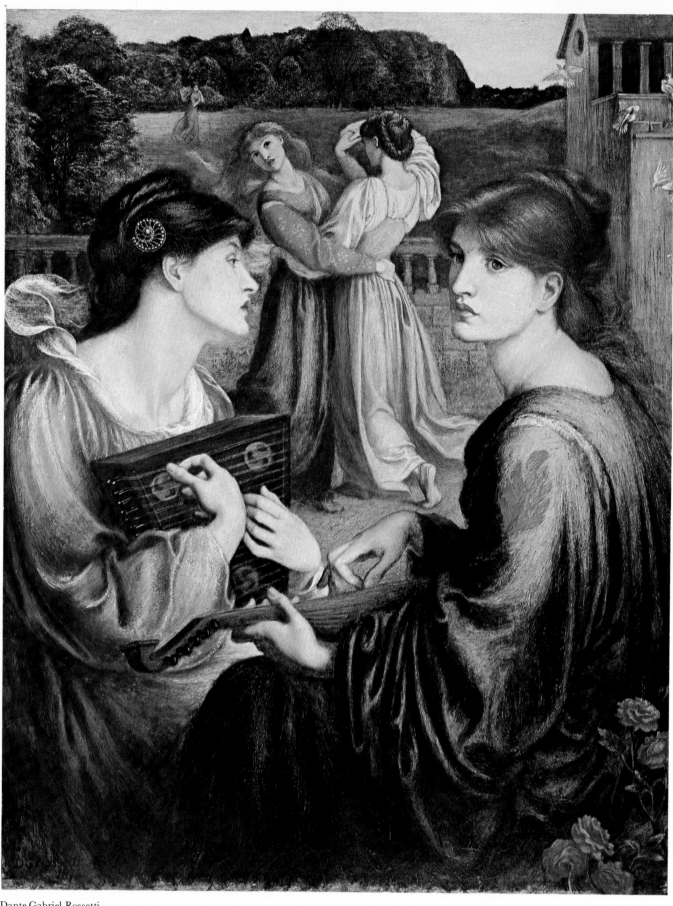

Dante Gabriel Rossetti

Dante Gabriel Rossetti

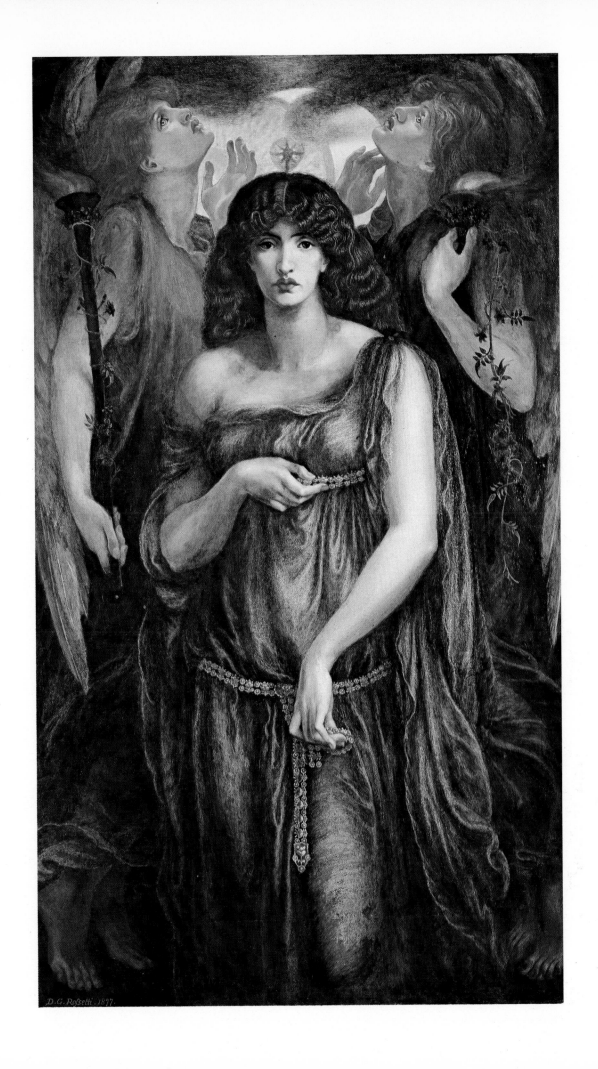

William Holman Hunt

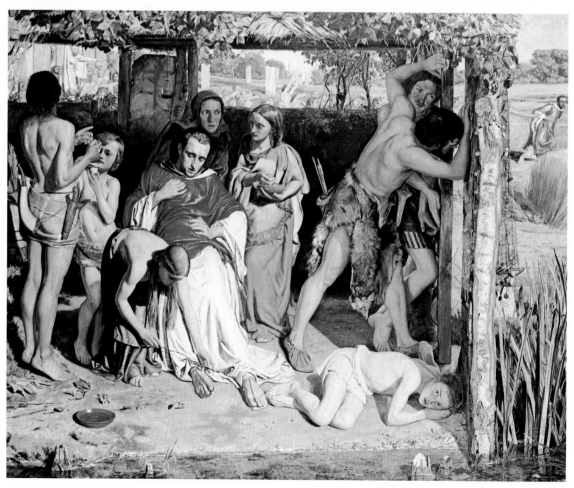

William Holman Hunt

William Holman Hunt

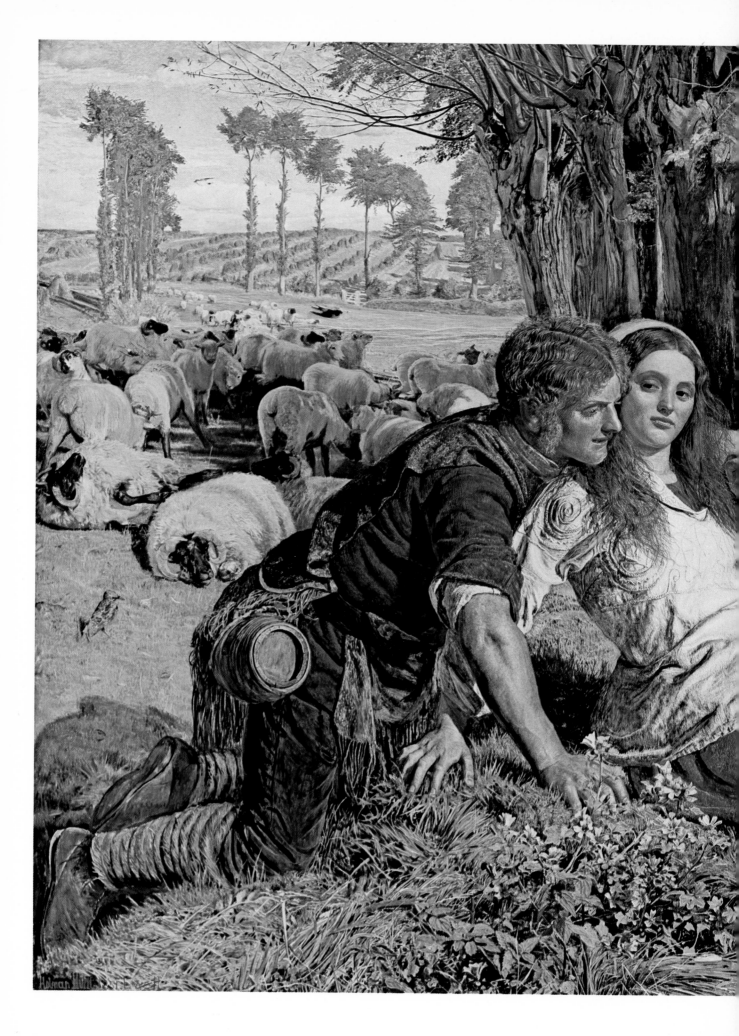

William Holman Hunt

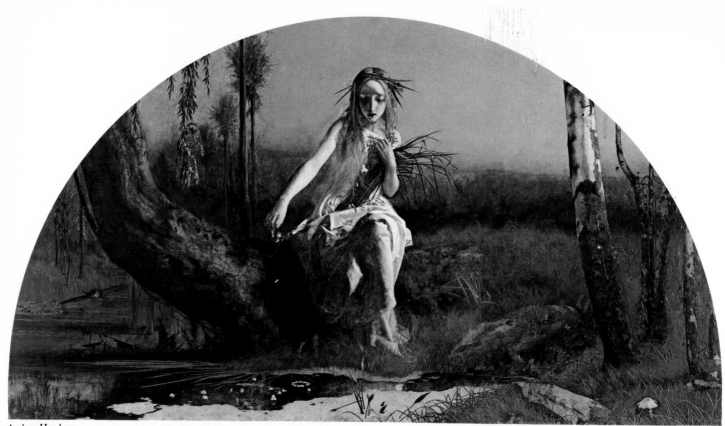

Arthur Hughes

John Brett

26

Arthur Hughes

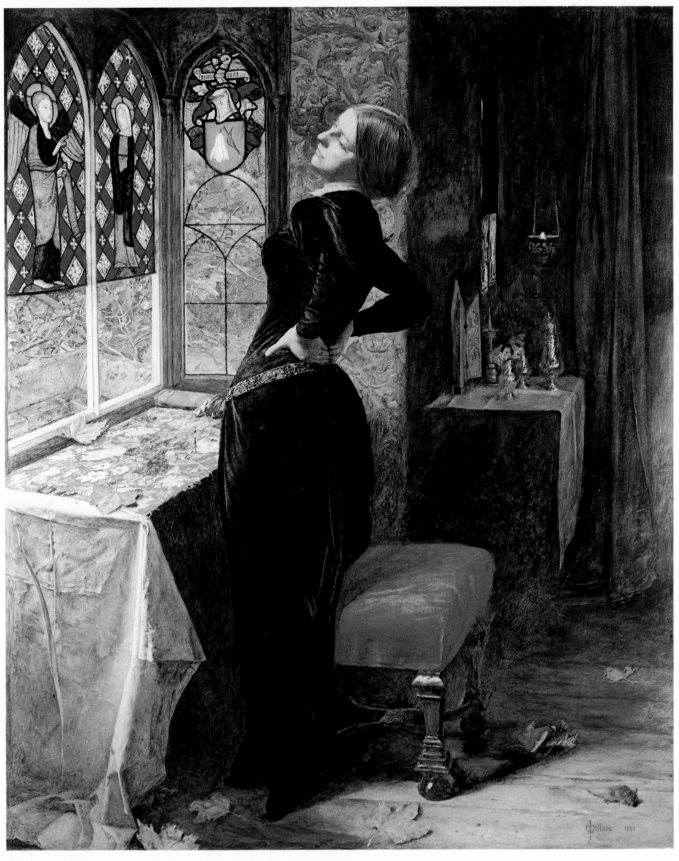

John Everett Millais

John Everett Millais

29

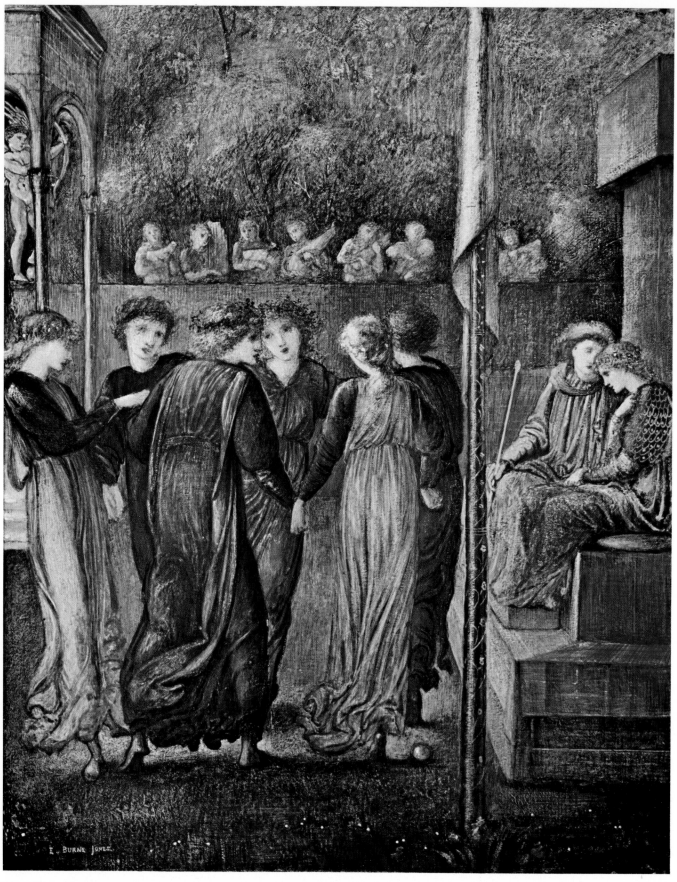

Edward Burne-Jones

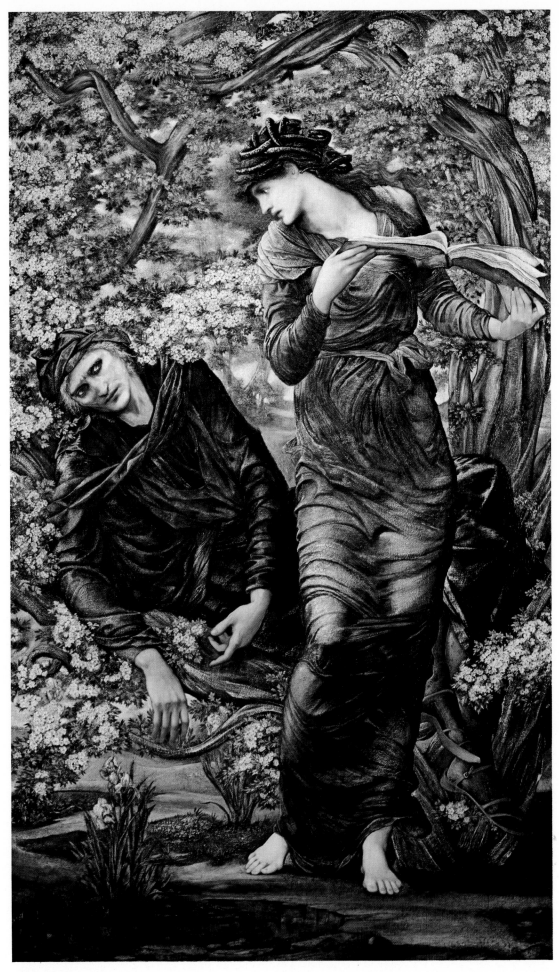

Edward Burne-Jones

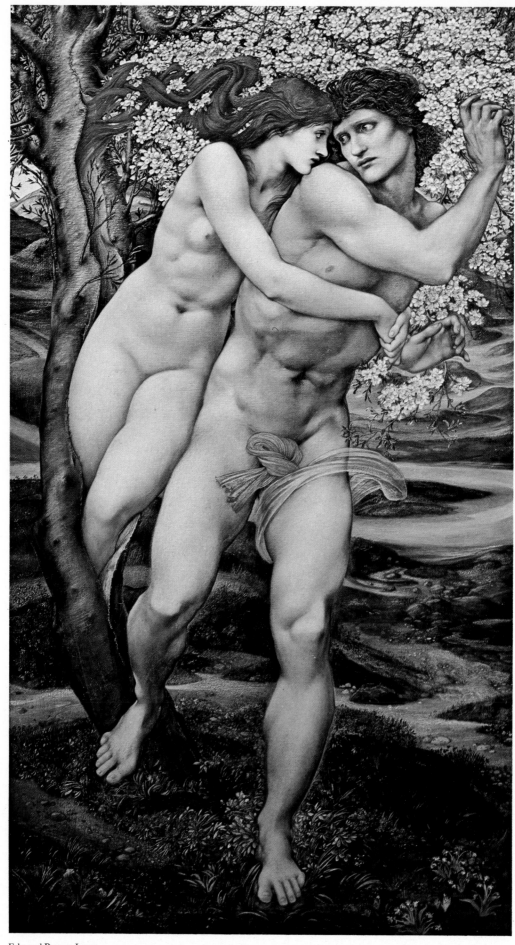

Edward Burne-Jones

WILLIAM BELL SCOTT
1811–1890

Poet, critic and painter, Bell Scott was the son of an engraver, and younger brother of the Scottish Romantic painter David Scott whose work is now virtually unknown. He was a friend of Rossetti, who was an admirer of his poetry, and contributed to *The Germ* in 1850. However, from 1843–1864 — and thus during the whole period of Pre-Raphaelite activity — he was Master of the Government School of Design in Newcastle, a circumstance which prevented his close involvement with the movement.

Bell Scott's works conform to Pre-Raphaelite ideals in the minute rendering of details which add to the impact of the message which his pictures seek to convey, but it was not Scott's habit to paint directly from nature in the accepted Pre-Raphaelite manner. His pictures dating from the 1860s, which are very Pre-Raphaelite in appearance, were, in fact, usually worked up from sketches.

Another feature of some of his paintings is the sharp differentiation between foreground and background levels, particularly apparent in the lesser known *Albrecht Dürer of Nuremberg* (1854) where the German artist is seen (paintbrushes in hand) standing on a balcony looking down upon mediaeval Nuremberg, depicted with a wealth of historic architectural detail. Bell Scott's topographical clarity emphasises, for example, the grain of the wood on the balcony where Dürer stands, and the individual stones and roof tiles of the city make this, in both subject matter and technical detail, an outwardly typical Pre-Raphaelite painting.

William Bell Scott
Albrecht Dürer of Nuremburg, 1854. Oil on canvas 28⅛ × 28¼ in.
(National Gallery of Scotland)

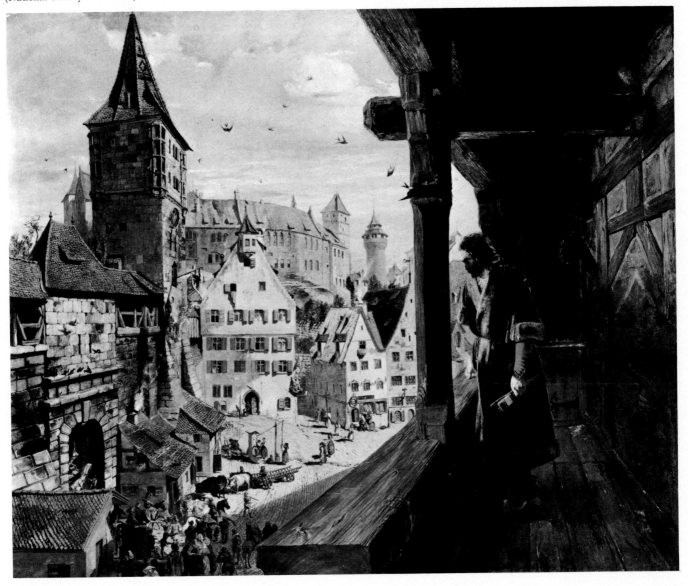

WILLIAM DYCE R.A.

1806–1864

Dyce was a generation older than the members of the P.R.B. and was already establishing himself as an artist at the time they were born. He was, however, one of their earliest and most fervent admirers and in the last years of his life spent his few hours of respite from the great task of decorating the Queen's Robing Room at the Palace of Westminster in experimenting with immensely detailed outdoor scenes in the Pre-Raphaelite manner.

Dyce was born in Aberdeen and studied medicine and theology there while painting secretly and against his parents wishes. After receiving encouragement from Sir Thomas Lawrence and paying an extended visit to Rome he returned to Aberdeen and openly practised painting. He completed a picture of *Bacchus nursed by the Nymphs of Nyssa* which was exhibited at the Royal Academy in 1827. Dyce paid a further visit to Rome where he made contact with the German Nazarene painters; their influence and that of Raphael and his followers are apparent in Dyce's work from this date. The period 1830–37 was spent in Edinburgh building up a successful portrait practice, and the next decade was mainly occupied with teaching, culminating in a trip to Italy where he studied the frescoes of the Old Masters.

Dyce was largely responsible for the revival of fresco-painting in England. After 1847, when he painted *Neptune resigning his Empire to Britannia* in fresco at Osborne House, the rest of his life was occupied with the mural decoration of the Queen's Robing Room. Two of the seven panels in this scheme were still uncompleted at the time of his death. The revival of interest in fresco was to have an important effect on painting technique. Experiments were made with the use of pale colours painted directly on to a white ground, thus greatly increasing the transparency of the work. Although the brilliance of Pre-Raphaelite colouring caused considerable comment when the pictures were first exhibited they were, in fact, simply continuing with experiments already undertaken some ten years before by Mulready.

The influence of the younger artists is clearly very strong in Dyce's Pre-Raphaelite pictures which exploit this effect of light. Contrary, however, to Pre-Raphaelite practice the landscapes were not painted directly onto the canvas in the open-air, but were worked-up from detailed sketches. Furthermore, a degree of pictorial organisation unknown to the Pre-Raphaelites is present even in the most minutely observed details of nature.

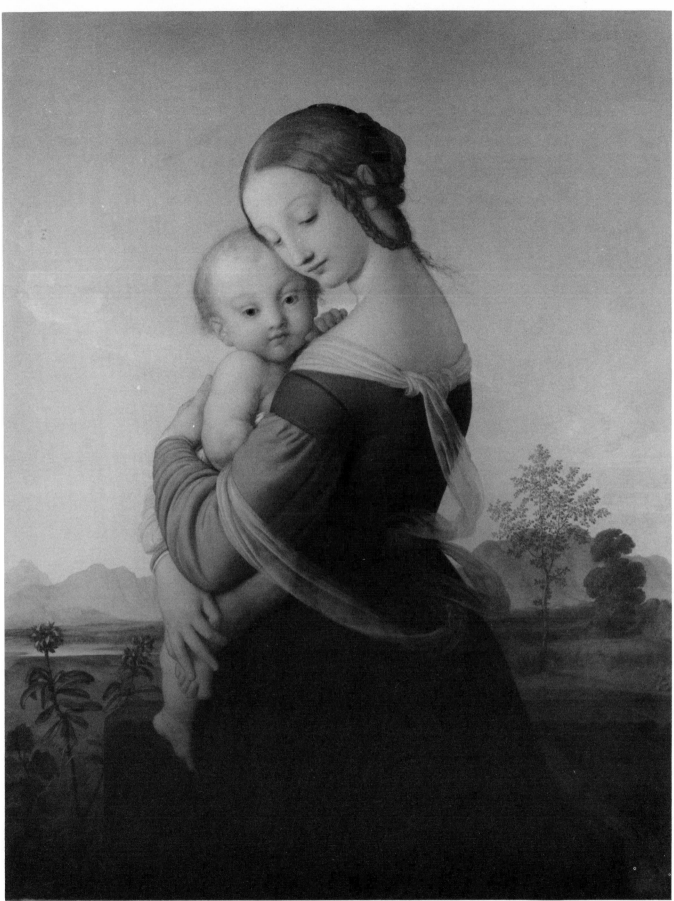

Opposite
William Dyce
George Herbert at Bemerton, 1861.
Oil on canvas 34 × 44 in.
(Guildhall Art Gallery, City of London)

Above
William Dyce
Madonna and Child, c.1827–30.
Oil on canvas 40½ × 31¾ in.
(The Tate Gallery, London)

THOMAS SEDDON

1821–1856

Seddon was the son of a successful furniture-maker and brother of John Pollard Seddon the architect and designer. His position in the world of architecture and furniture design was thus secured by family connections. He intended to go into the family business and so went to Paris in 1841 for a year to study ornamental design. On his return he applied himself to designing furniture, finally winning a prize for a sideboard design from the Society of Arts in 1848. Despite this success, he seems to have cherished aspirations as a fine artist, as he began to study drawing in the evenings during the following year. He was taught first by Charles Lucy, a member, with Madox Brown, of a group of expatriate artists who lived in Paris during the early 1840s. Lucy was a close friend of Madox Brown, with whom Seddon was later to study painting.

It is likely, therefore, that Seddon first met his instructors in Paris, and that his interest in fine art was nurtured there. Yet no trace of the influence of his year in Paris is apparent in his Pre-Raphaelite landscapes of the 1850s. These owe a debt initially to Madox Brown and later to Holman Hunt, with whom he worked in Egypt. J. P. Seddon, his brother, challenged the description of his works as 'Pre-Raphaelite' contending that Seddon himself had no wish to be identified with the Movement. His untimely death in Egypt in 1856 prevented him from elaborating the independent vein which began to emerge in his last works. Thus it is now impossible to judge whether he would have thrown off all trace of Pre-Raphaelite influence had he lived.

Thomas Seddon
The Great Sphinx at the Pyramids of Giza, 1854. Watercolour 9¾ × 13¾ in.
(Ashmolean Museum, Oxford)

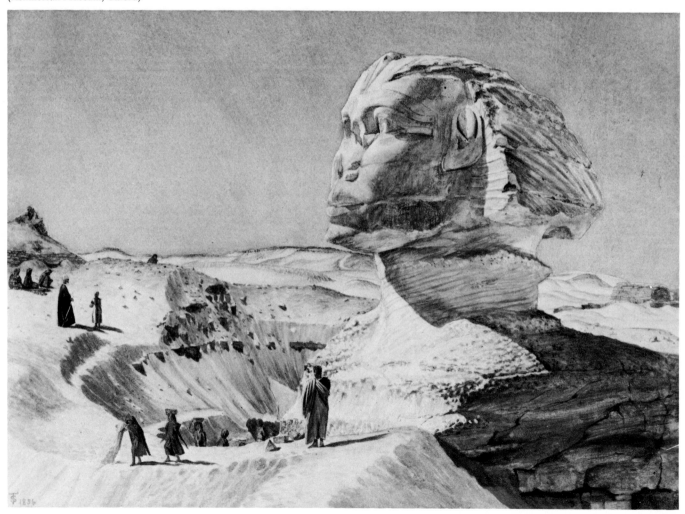

FREDERICK GEORGE STEPHENS

1828–1907

The inclusion of Stephens in the original Pre-Raphaelite Brotherhood is as curious as the omission of Deverell. At the time of his election he had not produced, according to William Michael Rossetti 'any picture adapted for exhibition' nothing in short but 'two or three good portraits on a small scale'. It is possible that the other P.R.B's were attracted by his 'thoughtful and picturesque' appearance. Indeed, he was to serve as the model for Ferdinand in Millais' painting *Ferdinand Lured by Ariel* (1849), for Jesus in Madox Brown's *Jesus Washing Peter's Feet* (1852–56), and for a background figure in Millais' *Lorenzo and Isabella* (1849).

Stephens was the son of an official at the Tower of London. He lived with his family in extremely modest circumstances in Lambeth, and was not able to add to their meagre resources by his painting. This, combined with the fact that he was intensely self-critical, led him to give up painting in the early 1850s and to make a career as a critic and teacher. He spent many years as the art critic of *The Athenaeum*, supplementing this employment with a post as an art teacher at University College School.

In 1867 Stephens published *Memorials of William Mulready*, a study of an artist who had a profound influence on the Pre-Raphaelites. Echoes of his painting are found throughout the P.R.B. works, and both his preoccupation with the accurate rendering of nature and his experiments with

transparency (achieved by using light, brilliant colour over a white ground) were eagerly assimilated and imitated.

When he gave up painting Stephens destroyed all but three of his pictures. The survivors must have been overlooked at the time of the holocaust, and were found after his death hidden in a lumber-room. The most finished and successful of these, *Mother and Child* (c. 1854) shows an apparently happy domestic scene fraught with undertones of tragedy. The child merrily solicits the mother's attention by his ploys, but she cannot respond as she is stunned by the news contained in a letter she holds in her hand. A fierce glittering light falls with merciless impartiality on the details of the room and its occupants. Both the moral significance and the careful 'truth to nature' demanded by Pre-Raphaelitism are presented in this work, and it would be interesting to know in what way the destroyed paintings failed to come up to Stephens' expectations. The two other surviving works are much less satisfactory.

The subjects tackled in the surviving works show that Stephens made a real attempt to become a Pre-Raphaelite. W. M. Rossetti's description of his student works suggest that he, like Collinson, R. B. Martineau and John Brett, was diverted from a natural inclination towards portraiture which, being less demanding, might have been sustained in later years.

Frederick George Stephens
Mother and Child, c.1854. Oil on canvas 18½ × 25¼ in.
(The Tate Gallery, London)

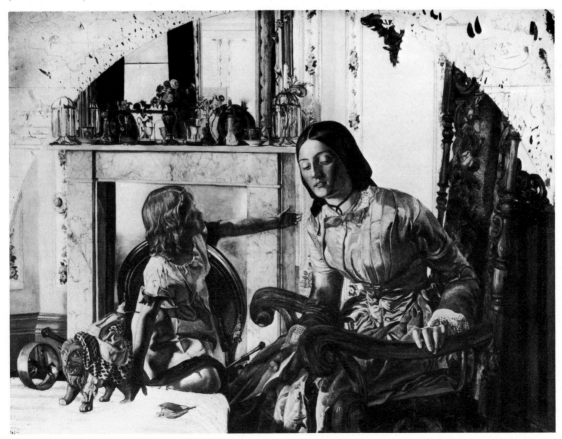

WILLIAM LINDSAY WINDUS

1822–1901

The son of wealthy Liverpool parents, Windus studied painting at the Liverpool Academy. His early works show the influence of Etty, and his subject matter deals with literary or historical anecdote. There is a curious tendency to illustrate obscure subjects in his later work. *The Outlaw* (1861), with its almost neurotic suppression of the ostensible subject, is a good example of this.

Windus was converted to Pre-Raphaelitism in 1850 when he was confronted with Millais' *Christ in the House of His Parents* (1849) at the Royal Academy. During the 1850s Windus, a slow and self-critical worker, produced two Pre-Raphaelite pictures: *Burd Helen* (1856), depicting a heart-rending subject taken from an ancient Scottish ballad, and *Too Late* (1858), a depressing treatment of a favourite Victorian theme — that death will intervene before good intentions can be put into effect. *Burd Helen* was reviewed enthusiastically by Ruskin, but the subject-matter of *Too Late* defeated him, and his consequent outburst of criticism so

depressed Windus that he was almost unable to continue with his artistic career.

All his later work, much of which he destroyed, was in the form of small pictures or sketches done for his own pleasure. *The Outlaw* is really a landscape, although a quick search through the undergrowth reveals the hunter and the hunted, the only spots of colour in an otherwise uniformly green picture. *The Strayed Lamb* (1864) is likewise a landscape with only a minute subject in the foreground. Both of these retain a Pre-Raphaelite attention to detail in the observation of the foliage and grass, and the subject-matter, in so far as it exists at all, is in the Pre-Raphaelite taste. Apparently Windus was never tempted to return to the dramatic and more fluent style of his youth. It is possible, therefore, to speculate that the demanding Pre-Raphaelite technique may have played as great a part in inhibiting his output in later life as his own self-critical temperament.

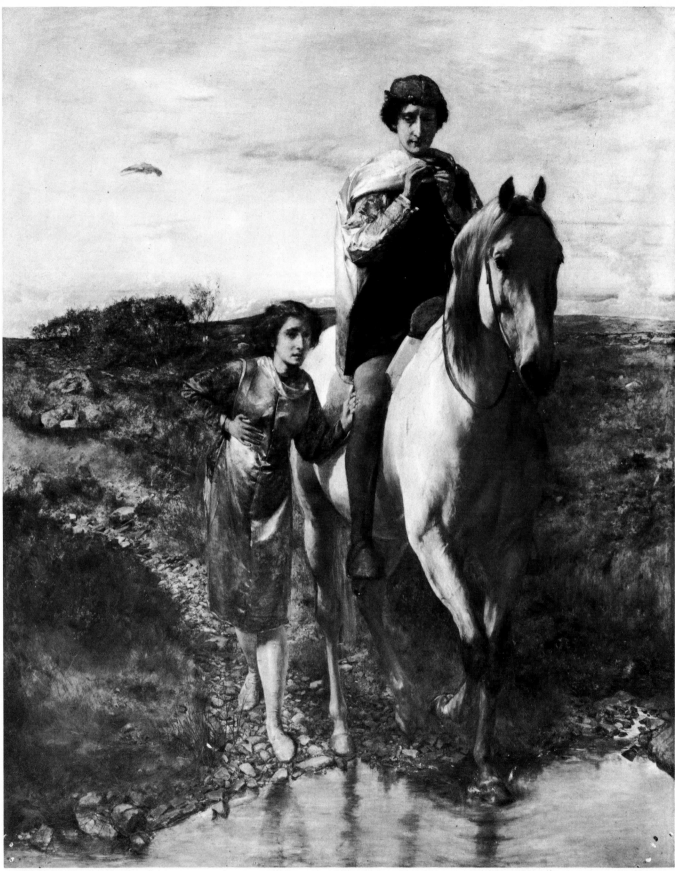

Opposite
William Lindsay Windus
The Outlaw, 1861.
Oil on canvas 13 × 12½ in.
(City of Manchester Art Galleries)

Above
William Lindsay Windus
Burd Helen, 1856.
Oil on canvas 33¼ × 26¼ in.
(The Walker Art Gallery, Liverpool)

GEORGE PRICE BOYCE
1826–1897

Boyce was born in Bloomsbury and the circumstances of his later life suggest that his family were rich enough to endow their son with independent means. He studied as an architect, entering the office of Messrs Wyatt and Brandon in 1846. Although he pursued his career for only three years traces of his training are detectable in his art, both in the choice of subject and in the confident and knowledgeable handling of the buildings which form the main motif of almost all his pictures. In 1849 a meeting with David Cox was to prove the turning point of his life. Although David Cox was, to all intents and purposes, Boyce's first and only master, the influence of his work is apparent for only a brief period.

Boyce's love of accurately observed detail, which was apparent even in his early architectural sketchbooks, led him inevitably to the practice of a modified Pre-Raphaelitism. At the very outset of his career as a painter he had been introduced by Thomas Seddon to Rossetti, with whom he rapidly made friends, becoming a faithful and perceptive patron of Rossetti. In spite of this friendship there was no trace of Rossetti's influence on his work. He seems to have been content to pursue certain limited objectives with persistence, for which he was rewarded with a small but unvarying success. He was, by temperament, an amateur and always parted with his work with a certain reluctance born of an incapacity to believe that anyone could truly desire to possess one of his pictures. Yet he did not lack important admirers.

Boyce exhibited first at the Pre-Raphaelite Exhibition in Russell Place in 1857, and thereafter at the Hogarth Club (1858–61). He also exhibited regularly at the Old Watercolour Society until nearly the end of his life, and sporadically at the Royal Academy. Boyce was probably protected from the more enervating effects of contact with the Pre-Raphaelite circle by his position on its fringes. Even his encounters with Ruskin (whom he met through Rossetti in 1854) are recorded as being, in his own words, 'pleasant and encouraging'.

George Price Boyce
The Mill on the Thames at Mapledurham, 1860. Watercolour 10½ × 22 in.
(Fitzwilliam Museum, Cambridge)

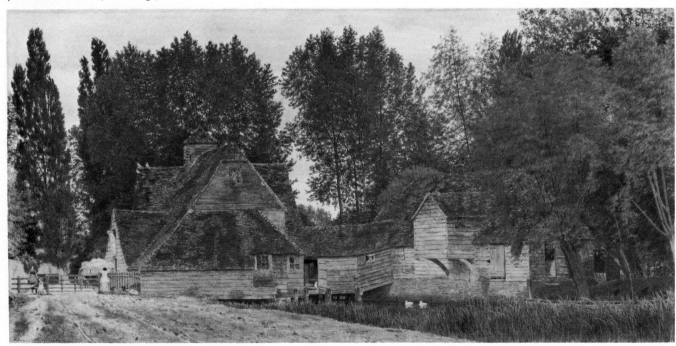

ROBERT BRAITHWAITE MARTINEAU

1826–1869

Martineau spent some time in a solicitor's office and so entered the Royal Academy Schools rather late. In 1851 he went to study with Holman Hunt and immediately embarked on a subject from *The Old Curiosity Shop* by Dickens, painted under Hunt's direction. *Kit's Writing Lesson*, a canvas crowded with all the mingled paraphernalia of the 'Curiosity Shop', was exhibited at the Academy in 1852. In spite of a superficially Pre-Raphaelite quality in the technique and the observation of detail, the absence of romantic or moralistic intensity makes this more like a narrative painting. *The Last Chapter*, painted ten years after *Kit's Writing Lesson*, has the poetic quality to which he aspired. Similarly, the unfinished *Poor Actress' Christmas Dinner*, also painted under Holman Hunt's tutelage in 1855, might have been a fully realized Pre-Raphaelite work as it has the quality of pathos which his *Christmas Hamper* so defiantly repudiates.

Martineau shared Holman Hunt's studio intermittently until 1865. Later works confirm that his propensity, like Collinson's, was for narrative or anecdotal painting and he himself regarded *The Last Day in the Old Home* (1862), with which he was occupied during the last years of his life, as his masterpiece. This painting, crammed with incident and significant detail, is one of the best known nineteenth century 'story' pictures and a worthy example of the Victorian narrative tradition.

Robert Braithwaite Martineau
Kit's Writing Lesson, 1852. Oil on canvas 20½ × 27¾ in.
(The Tate Gallery, London)

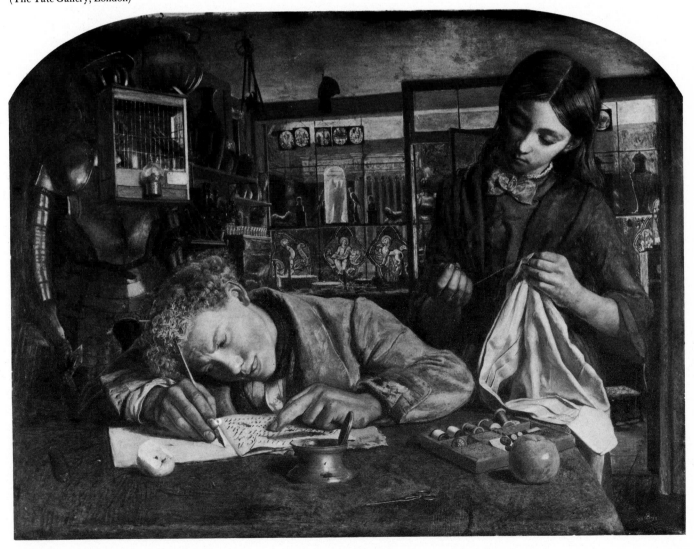

WALTER HOWELL DEVERELL

1827–1854

Deverell's painting career was tragically brief. The promise shown in his surviving works suggests that, had he not died at the age of twenty-six, he might have been the one painter of the Pre-Raphaelite circle able to reconcile Pre-Raphaelitism with a breadth of vision which the other members so conspicuously lacked.

Deverell was the son of the secretary at the School of Design and was an intimate friend of Rossetti whom he had known since the days at Sass's Drawing School in 1845. He later came to know both Millais and Holman Hunt. His omission from the original Brotherhood is curious. A possible explanation is that he already held a post at the Government School of Design to which he was appointed in 1848. It was later proposed that he should take the place vacated by Collinson in 1850, but he was never officially elected.

In 1851 he joined Rossetti in the studio in Red Lion Square, later to be occupied by Morris and Burne-Jones. There he completed his *Scene from 'As You Like It'*, exhibited at the Academy in 1853, following two other Shakespearean subjects, *Scene from 'The Twelfth Night'* (1850) and the *Banishment of Hamlet* (destroyed). In 1852 he began three figure subjects: a *Portrait of Miss Margaret Bird and Miss Jessie Bird* (destroyed), *The Grey Parrot*, and the similar *Lady Feeding a Bird* (known as *A Pet)* which was painted in the garden of the house at Kew where his family lived from 1850 to 1853. His only painting with a moralising subject, *The Irish Vagrants*, whose exact significance is obscure, was never completed.

The absence of didacticism and moral purpose in Deverell's pictures has led to his work being undervalued. It has even been said that his most valuable contribution to Pre-Raphaelitism was the discovery, in a milliner's shop in 1849, of Elizabeth Siddal (later Rossetti's wife). Crucial though Miss Siddal was to the development of Rossetti's artistic imagination, this view of Deverell's artistic importance does him far less than justice.

Walter Howell Deverell
Twelfth Night, 1850.
Oil on canvas 40¼ × 52½ in.
(Leger Galleries, London)

Opposite
Walter Howell Deverell
A Pet, 1852–3.
Oil on canvas 33 × 22½ in.
(The Tate Gallery, London)

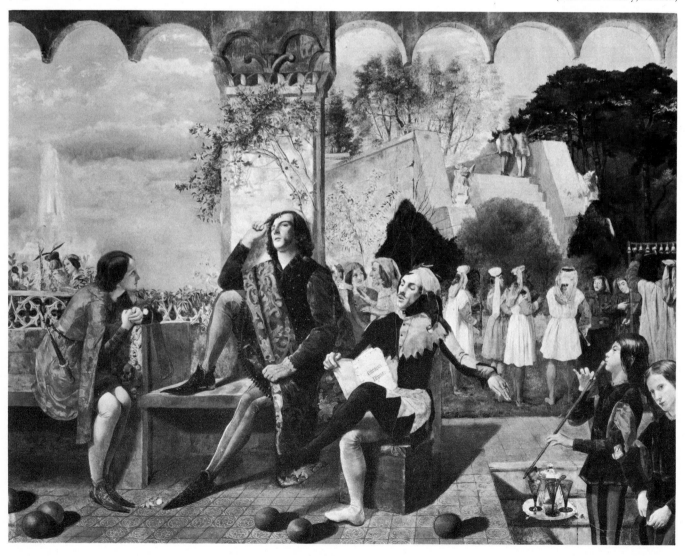

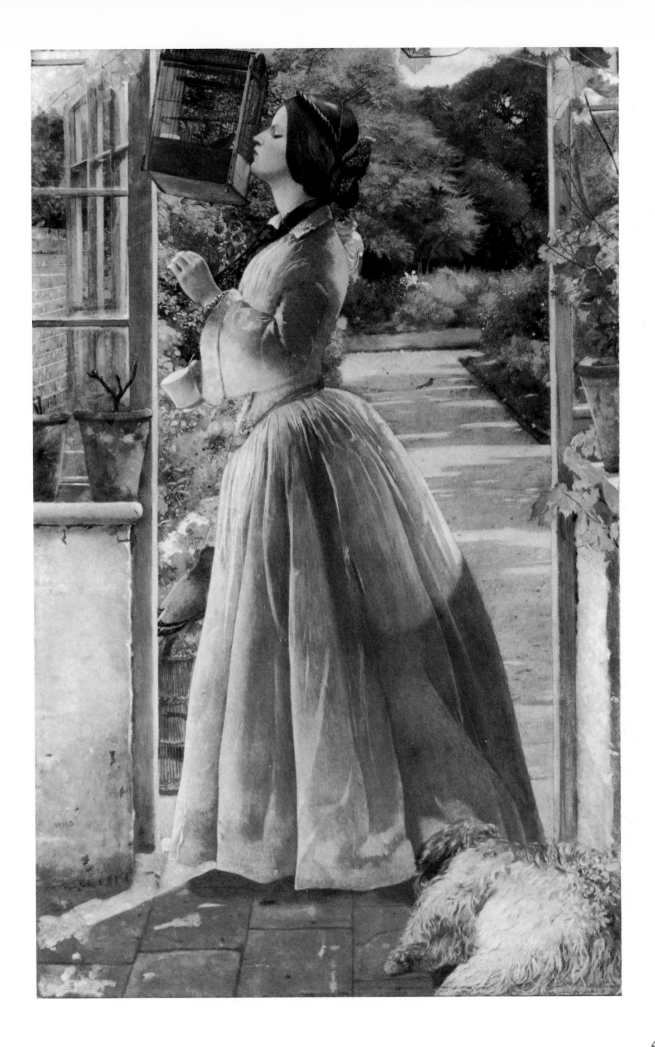

CHARLES ALLSTON COLLINS
1828–1873

C. A. Collins was the younger son of the artist William Collins R.A. and the brother of the novelist Wilkie Collins. The youthful Collins showed such a promising talent that Sir David Wilkie, a close friend of his parents, declared that he should be a painter. Collins was a fellow student with Millais at the Royal Academy Schools and was proposed as a member of the P.R.B. by Millais — along with Deverell — at the time of Collinson's withdrawal in 1850. He was rejected, according to Holman Hunt, on the grounds that he was unknown to other members and thought to be 'very much of a conventional man who would be out of his element with us'. The rejection was said to have 'cut Collins to the quick'. He had, in fact, turned away from the conventional style of his student days, largely imposed upon him by childhood encounters with his father's artist friends, to paint his first Pre-Raphaelite picture, *The Pedlar* (exhibited 1850) under the influence of Millais. This was followed in 1851 by *Convent Thoughts,* a subject reflecting his increasing commitment to 'high-church' beliefs, which again shows his debt to Millais.

Identified by the critics with the Pre-Raphaelite movement, Collins suffered the same unfavourable reception as his friends. Ruskin singled out his picture, however, in the letter written in defence of the P.R.B. and praised it for the accurate observation of the plants. Collins continued to paint throughout the 1850s exhibiting at the Royal Academy, the Liverpool Academy and the 1857 Pre-Raphaelite Exhibition in Russell Place, but eventually gave up painting and devoted the remainder of his life to writing.

Charles Allston Collins
Berengaria's alarm for the safety of her husband, Richard Coeur de Lion, awakened by the sight of his girdle offered for sale at Rome (The Pedlar), 1850.
Oil on canvas 39⅞ × 42 in.
(City of Manchester Art Galleries)

Opposite
Charles Allston Collins
Convent Thoughts, 1851.
Oil on canvas 33⅛ × 23¼ in.
(Ashmolean Museum, Oxford)

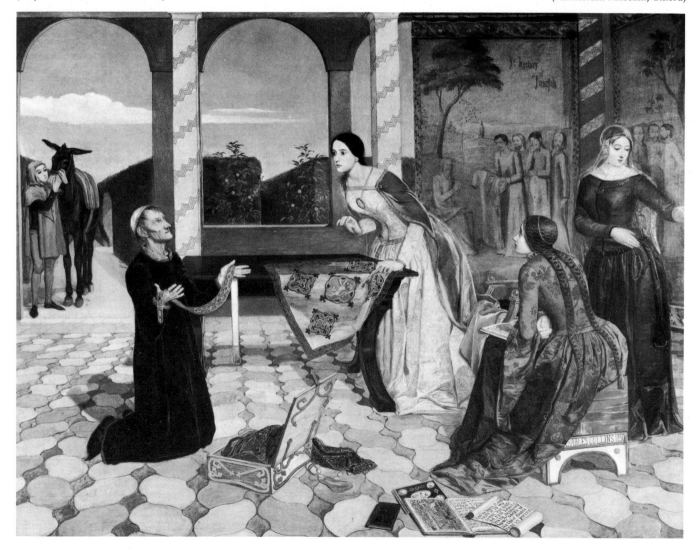

JAMES COLLINSON
1825–1881

Although one of the original members of the Pre-Raphaelite Brotherhood, Collinson was by inclination a *genre* painter. His ability to present a domestic scene with a wealth of carefully executed detail led Rossetti to believe that he would be a suitable member of the Pre-Raphaelite Brotherhood, against the advice of Millais and Holman Hunt, who rightly foresaw his lack of poetic inspiration. Apart from his one Pre-Raphaelite picture, *The Renunciation of Queen Elizabeth of Hungary*, (1851) his subjects were almost invariably domestic or anecdotal, directly related (both in execution and subject matter) to the popular narrative paintings of the period. This can be seen clearly in *Answering the Emigrant's Letter* also completed about 1850.

The son of a Nottingham bookseller, Collinson was a contemporary of Rossetti, Millais and Holman Hunt at the Royal Academy Schools. At the time of the formation of the Pre-Raphaelite Brotherhood he was a recent convert to Catholicism, but he fell in love with Rossetti's sister Christina who was a devout Anglican. She made it a condition of her acceptance of his proposal of marriage that he should renounce the Catholic faith, which he duly did in 1849. His impulse towards Catholicism was too strong, however, so he resigned from the P.R.B. and entered Stonyhurst as a Jesuit novice in 1850. After about four years he resumed his career as an artist, but did not seek to renew his contact with the Pre-Raphaelites. His work reverted to the chosen style of his student days, and he continued to produce rather insipid *genre* subjects until his death.

James Collinson
The Renunciation of Queen Elizabeth of Hungary, 1851.
Oil on canvas 47⅜ × 71½ in.
(Johannesburg Art Gallery, Joubert Park, Johannesburg)

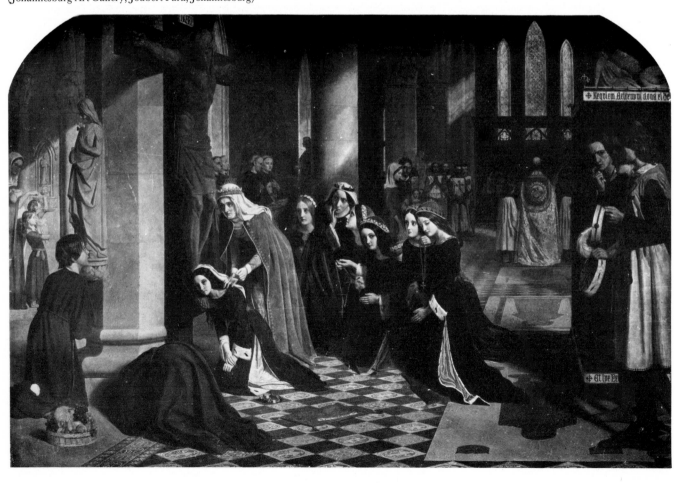

James Collinson
Childhood, 1855.
Oil on canvas 17¼ in. diameter
(The National Gallery of Canada, Ottawa)

FORD MADOX BROWN

1821–1893

Madox Brown was never a member of the Pre-Raphaelite Brotherhood although he was closely associated with them and was the only member of their circle to make a contribution to the Movement comparable with that of the three main artists, Holman Hunt, Rossetti and Millais. His election was discussed and rejected. In fact, if he had been approached he might have refused to join a hot-headed group of revolutionaries who were all some years younger than himself. His involvement with the Movement was, however, as complete as that of any official member of the P.R.B. Much of his work on their behalf was practical, taking the form of organising an exhibiting society and involving himself in Morris's venture into commercial decoration.

Madox Brown was born in France and was one of the four members of the Pre-Raphaelite circle to have extensive experience of European artistic ideas. His entire artistic training was undertaken abroad. He studied in Bruges under Albert Gregorius and in Ghent under Pieter van Hansel, both pupils of the great neo-classical painter, David. Finally, he studied under the renowned history-painter Gustave, Baron Wappers in Antwerp. The effects of this training are apparent in Madox Brown's pictures, particularly in his ability to organise complex groups of figures, a talent conspicuously lacking in, for example, Holman Hunt.

In 1840 Madox Brown was in Paris, studying the work of Rembrandt and the early Spanish painters at the Louvre, and Delaroche and Delacroix amongst the artists of the preceding generation. At this date he made his first experiment with the outdoor effects of light in *Manfred on the Jungfrau,* now much altered by later re-painting — like so many of the Pre-Raphaelite pictures. During this time he visited England and began exhibiting at the Royal Academy. He married in Paris, and his daughter, Lucy (who later married William Michael Rossetti) was born in 1843. In 1844 he settled in England and shared a studio with the painter Charles Lucy, submitting three cartoons to the Westminster Hall competition for the frescoes in the Houses of Parliament. His wife's health deteriorated in the English climate and in 1845 the family moved to Rome. Despite the move she died in 1846. While in Rome Madox Brown made contact with the German Nazarene painters, and their influence is apparent in his work from this date.

Soon after his re-establishment in London Madox Brown began his first major work, *Chaucer at the Court of Edward III.* It was not completed until 1851 when it was exhibited at the Royal Academy. This painting was identified with the still unpopular Pre-Raphaelite works and received correspondingly adverse notices. Another similar historical subject was painted concurrently with the *Chaucer,* but *Wycliffe reading his translation of the Bible to John of Gaunt in the presence of Chaucer and Gower* was completed much earlier and exhibited in 1848, the year in which Rossetti introduced himself to Madox Brown and became, for a short time, his pupil.

From 1848 to 1863/4 Madox Brown's pictures can be regarded as entirely Pre-Raphaelite works. They were executed under the Pre-Raphaelite ideals of truth-to-nature and unadorned realism of subject-matter on the intractable wet-white ground. Madox Brown often worked out of doors in conditions of considerable difficulty and discomfort. He continued with dogged disregard for unfavourable criticism, pursuing a financially disastrous course. Throughout his career he enjoyed only one period of relative prosperity lasting less than ten years, when he managed to attract the attention of a number of new patrons after 1865. His Pre-Raphaelite pictures often sold for sums as small as ten pounds, twenty pounds and forty pounds. Brown's letters are full of references to 'pot-boiling' work undertaken to support his family, for he had remarried and had two more children.

The pictures produced by Madox Brown during his Pre-Raphaelite phase are amongst the most significant contributions to the Movement. The modern life subjects are depicted without the sentimentality which mars the later pictures by Arthur Hughes or the excessive morbidity of *Too Late* by W. L. Windus. In spite of the social comment in the details of his most ambitious picture, *Work,* the whole composition remains legible unlike, for example, Holman Hunt's *The Awakening Conscience.* Madox Brown was occupied for over twelve years with *Work,* and his explanation of the significance of the various elements of the picture cover no less than five pages of the catalogue issued at the time of the exhibition of his work, which he organized and paid for himself. It was during the period immediately following his exhibition that Madox Brown enjoyed a small measure of prosperity.

In *Work* Madox Brown has made his heroic central figure 'the British excavator, or *navvy,* as he designates himself' (catalogue note). Brown goes on to say that he believes this figure to be as worthy of the English artist's attention as 'the fisherman of the Adriatic, the peasant of the Campagna, or the Neapolitan lazzarone'. This is not a view that was widely shared by the picture buying public who did not like working men or biblical figures shown as common people without the customary spiritual and uplifting expression.

Madox Brown's *Jesus Washing Peter's Feet* was criticised for this reason when it was exhibited in 1852; in the same year *The Pretty Baa-Lambs* was badly received as the critics failed to find a message in the composition. Madox Brown's experiences with the critics show the difficulties of making Pre-Raphaelitism acceptable to the public. The pictures were found to be blasphemous or excessively high-church, sordid or meaningless, and too detailed or clumsy in execution — an inevitable hazard of striving towards absolute truth to nature. Even Ruskin, whose support had gone so far as to explain in a lengthy letter to *The Times* the exact significance of the innumerable accessories in *The Awakening Conscience* was discouraged by the depressing subject matter of *Too Late.*

It is possible that Madox Brown would have had an easier and more prosperous career if he had stuck to the history paintings of the early 1840s. At the time the close attention to the exact rendering of natural light, which repudiated the usual practice of high-lighting and dramatising the central motif of a composition, was found puzzling. These works, however, fit logically into the European nineteenth century tradition, and similar pictures might have enjoyed a popular success.

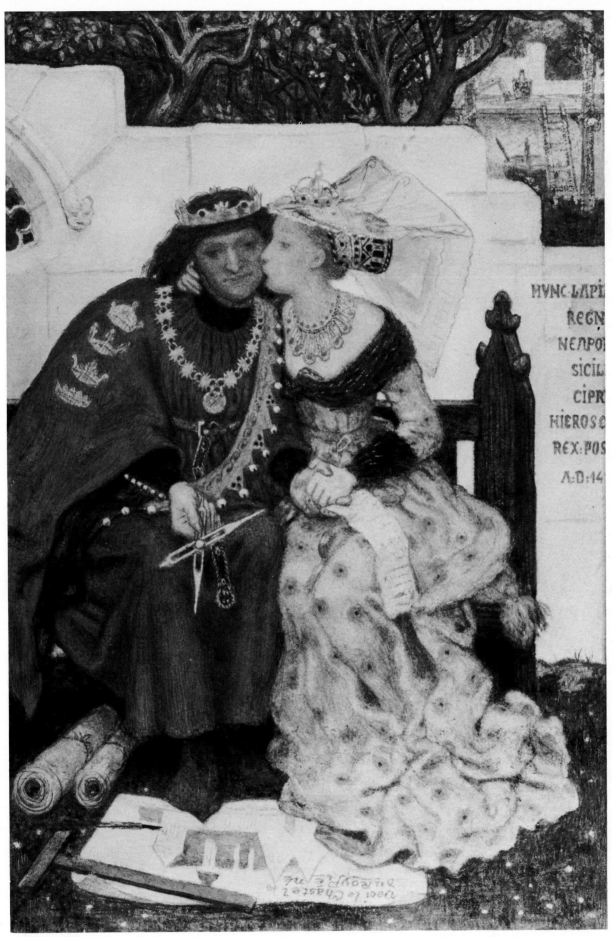

Ford Madox Brown
King Rene's Honeymoon, 1864. Watercolour 10¼ × 6¾ in.
(The Tate Gallery, London)

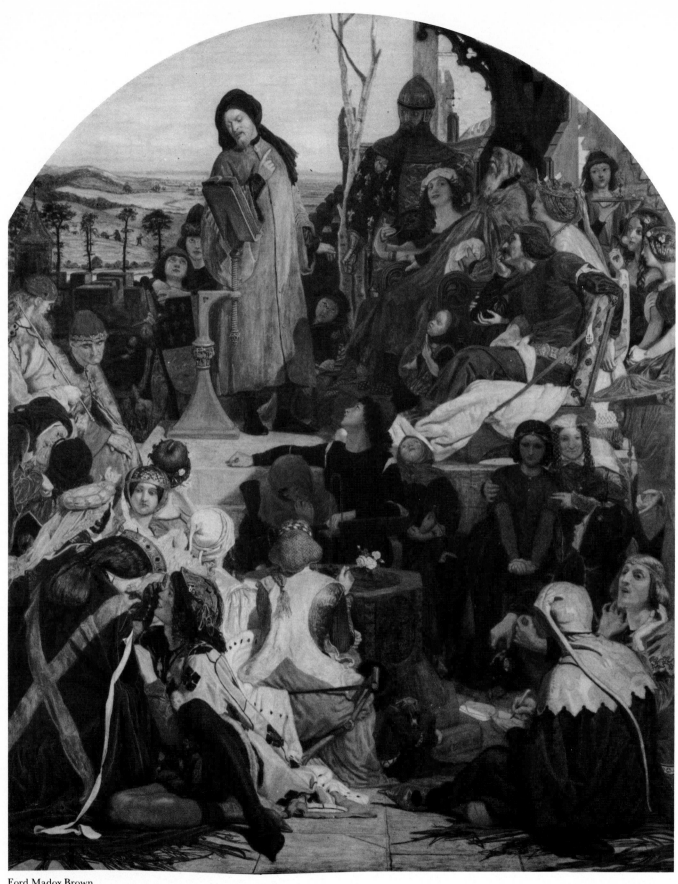

Ford Madox Brown
Chaucer at the Court of Edward III, 1856–68. Oil on canvas 48½ × 39 in. (Later version).
(The Tate Gallery, London)

50

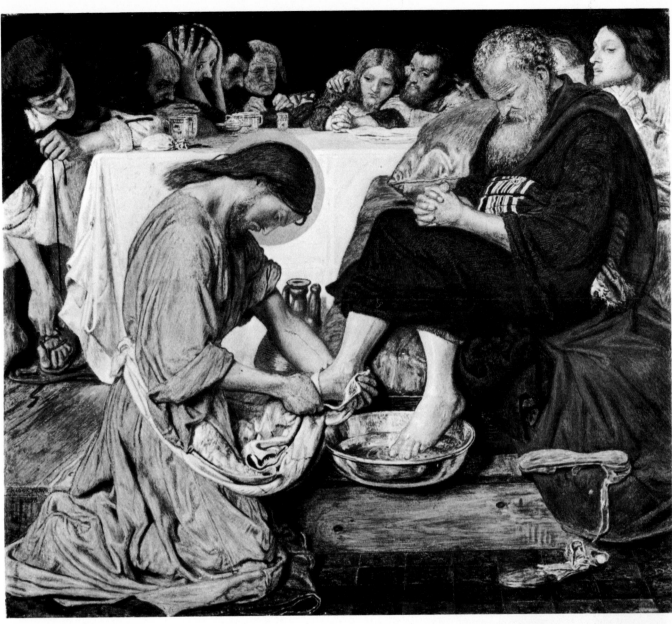

Ford Madox Brown
Jesus Washing Peter's Feet, 1852–6.
Oil on canvas 46 × 52½ in.
(The Tate Gallery, London)

Ford Madox Brown
Study for the Courtier in Yellow Hood (Chaucer), 1848.
Oil on board 60.9 × 46.6 cm.
(City of Manchester Art Galleries)

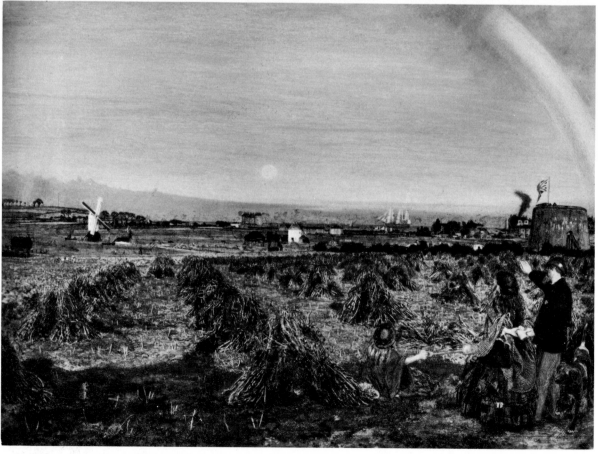

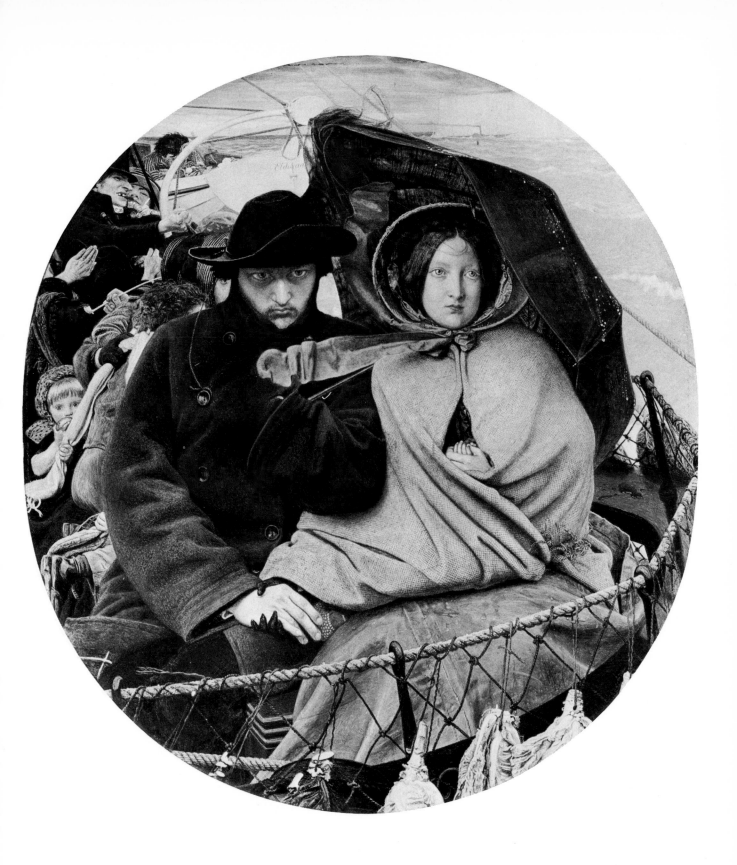

Opposite above
Ford Madox Brown
The Pretty Baa-Lambs, 1851–9.
Oil on panel 24 × 30 in.
(By courtesy of Birmingham Museums and Art Gallery)

Opposite below
Ford Madox Brown
Walton-on-the-Naze, 1859–60.
Oil on canvas 12½ × 16½ in.
(By courtesy of Birmingham Museums and Art Gallery)

Above
Ford Madox Brown
The Last of England, 1855.
Oil on panel 32½ × 29½ in.
(By courtesy of Birmingham Museums and Art Gallery)

WILLIAM HOLMAN HUNT
1827–1910

The basis for Pre-Raphaelite ideals lies in Holman Hunt's deep sense of moral purpose, and he wished to use realism and unconventional compositional devices to convey this viewpoint. He opposed the election to the P.R.B. of Madox Brown on the grounds that his conventional ideas for composition weakened the message which the picture should try to convey. It is fitting therefore that Holman Hunt alone should adhere to these principles, which he formulated at the outset of his career, throughout his life.

Holman Hunt was born in London, the son of a warehouse manager ambitious for his son's success in commercial life. Holman Hunt's wish to be a professional artist was not encouraged, though no obstacles were put in the way of his painting as an amateur in his spare time. Holman Hunt's determination overcame the obstacle of his father's disapproval and after two unsuccessful applications he was accepted as a probationer at the Royal Academy Schools in 1844. Here he became friendly with the sixteen-year-old infant prodigy, John Everett Millais, with whom he discussed his ideas about naturalism and composition, recognizing in Millais' extraordinary facility of hand and eye an ideal instrument to test his artistic theories.

In 1848 he exhibited *The Eve of St. Agnes*, the subject taken from Keats, whom he had read avidly in the previous year. The picture was seen at the Academy by Rossetti, who approached Holman Hunt with a request to be taken as a pupil. As with all his previous attempts to follow a course of instruction, Rossetti found Hunt's teaching tedious, and although Hunt was probably responsible for teaching Rossetti what little he knew about painting, the lessons rapidly became the sessions of discussion and argument from which the P.R.B. was to grow. Rossetti's first Pre-Raphaelite picture *The Girlhood of Mary*, was painted under Holman Hunt's direction in 1849.

Meanwhile Holman Hunt was working on his first outdoor subject, *Rienzi vowing to obtain justice for the death of his young brother, slain in a skirmish between the Colonna and Orsini factions*, the foreground and background painted directly onto the canvas in the open air. Though the picture was well received by the critics it remained unsold at the closing of the Academy exhibition, a matter of crucial importance to the artist who could only continue his career with the money from the sale of the picture. Finally, through the intervention of Augustus Egg it went to a collector named Gibbons who evidently did not particularly care for it as he never hung it on his walls. Financial uncertainty of this kind dogged Holman Hunt during the early years.

His 1850 Academy picture, *A Converted British Family sheltering a Christian Priest from the Persecution of the Druids*, was bought by Thomas Coombe's uncle-by-marriage at the suggestion of Millais. *Claudio and Isabella* (1850) was bought by Augustus Egg who had lent money to Holman Hunt to enable him to paint it. *Valentine rescuing Sylvia from Proteus* (1851) also remained unsold for some time and Millais again intervened this time with a loan of money, allowing Hunt to proceed with the painting of *The Hireling Shepherd* at Ewell in the summer of 1851. His situation gradually improved however, and unlike Madox Brown, his pictures began to sell for respectable sums of money. By the time he returned from his journey to the East he was in a position to ask over £5000

for *The Finding of the Saviour in the Temple* (1854–60).

Holman Hunt's trip to the East was undertaken in order to find material which would be absolutely 'true-to-nature' for his biblical subjects. In the event, difficulties with finding models and persuading them to pose in the right settings (the goats were particularly obstinate) led him to paint a number of pure landscapes while he was there, but on his return he forged ahead with the ambitious and complex *The Finding of the Saviour in the Temple* using English models to replace the reluctant orientals with whom he had had such difficulties two years before.

Before departing for the East Holman Hunt had already painted the picture that was his first popular success and was eventually to become the religious symbol of the age. In *The Light of the World* (1853–56) he found a completely congenial subject, and his work in later life was to be dominated by religious or biblical pictures with complex symbolic overtones — *The Shadow of Death* (1870–73), whose title is self-explanatory, *The Triumph of the Innocents* (1883–84), with its twenty-two ghost-infants and *The Scapegoat* (1854), which *The Times* admitted to finding 'difficult to divine the nature of the subject'. Two other pictures completed during the same period as *The Light of the World* contain less immediately obvious religious or moral symbolism, *The Hireling Shepherd* (1851), with its neglected and straying sheep, and *The Awakening Conscience* (1852), painted as the worldly counterpart to *The Light of the World*, whose title is again self-explanatory, (not that this deterred Ruskin from writing at considerable length to *The Times* explaining the significance of every detail). The intention is unquestionably to illustrate a religious idea even where, as in *The Hireling Shepherd*, the ostensible source is literary, in this case Edgar's song from *King Lear*.

Although Holman Hunt was to return to literary themes in his later work, both *Isabella and the Pot of Basil* (started in 1861), taken, like Millais' *Lorenzo and Isabella* from Keats' poem, and *The Lady of Shalott* (begun 1886–7), which is based on an illustration done for the Moxon *Tennyson* in 1857, revert to themes already present in his earliest work. As late as 1888 he was still working on a subject that had, he claims, first occurred to him in the 1850s, in this case *May Morning on Magdalen Tower*, depicting the Christian celebration of a festival of Druidical origin. This was to be one of his last undertakings, occupying him until 1890. In 1892 he again set out for the East in order to paint *The Miracle of the Holy Fire*, which was to occupy him until 1899. Hunt was fascinated by this scene of religious fanaticism, but his picture fails to suggest the full horror of this event. It is described from contemporary accounts, in a biography of the artist published in 1936, as resulting in between two hundred and four hundred dead, trampled underfoot in the hysteria at the appearance of the holy fire.

Shortly after painting this picture Holman Hunt's eyesight began to fail, and his unfinished work was completed with the help of an assistant. In 1905 *Pre-Raphaelitism and the Pre-Raphaelite Brotherhood* was published. Holman Hunt's remarkable memory enabled him to present the history of the Movement with such a mass of detail that it remains one of the prime source books for the history of the Pre-Raphaelites.

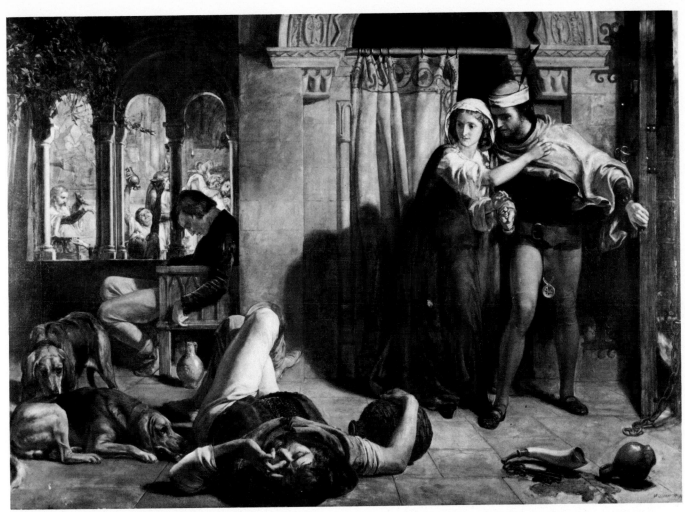

William Holman Hunt
The Eve of St. Agnes, 1848. Oil on canvas 30½ × 44½ in.
(Guildhall Art Gallery, City of London)

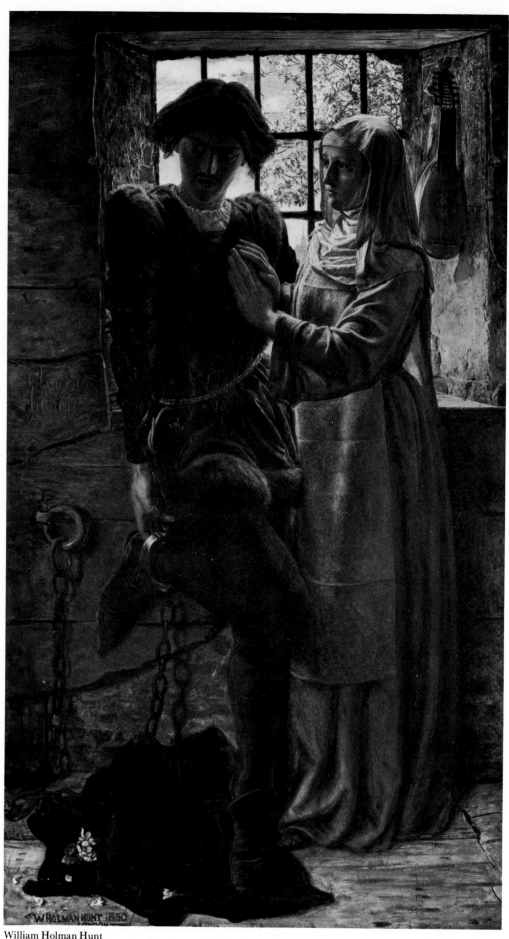

William Holman Hunt
Claudio and Isabella, 1850. Oil on panel 30½ × 18 in.
(The Tate Gallery, London)

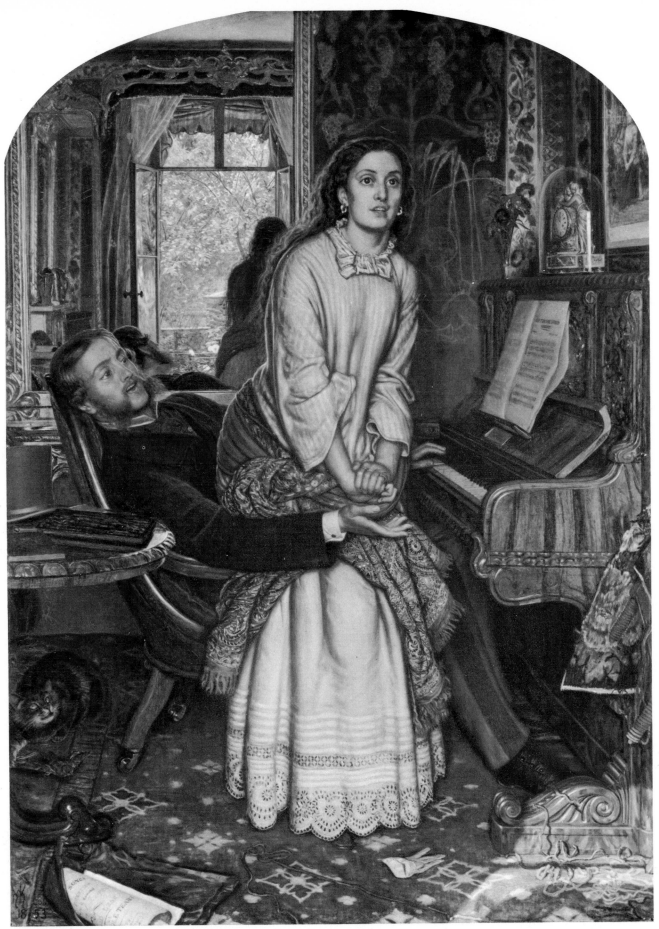

William Holman Hunt
The Awakening Conscience, 1852. Oil on canvas 29¼ × 21⅝ in.
(The Tate Gallery, London)

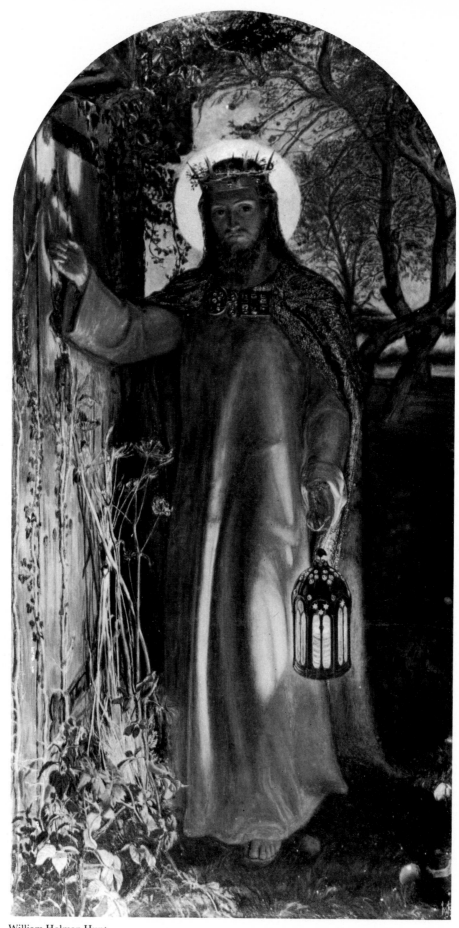

William Holman Hunt
The Light of the World (original sketch for the painting at Keble College, Oxford), 1853–6.
Oil on canvas 19¾ × 10⅜ in.
(City of Manchester Art Galleries)

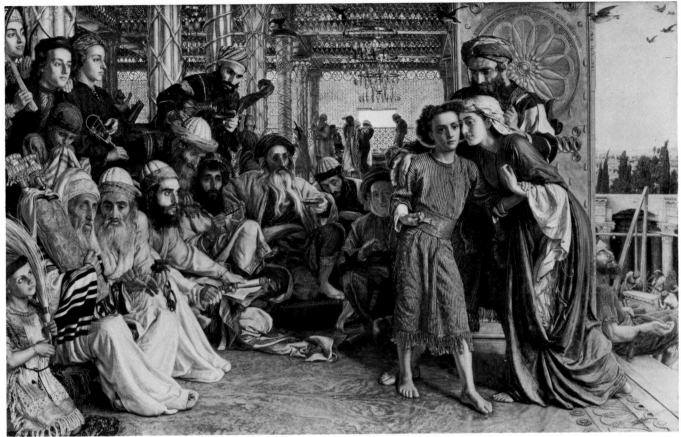

William Holman Hunt
The Finding of the Saviour in the Temple, 1854–60. Oil on canvas 33¾ × 55½ in.
(By courtesy of Birmingham Museums and Art Gallery)

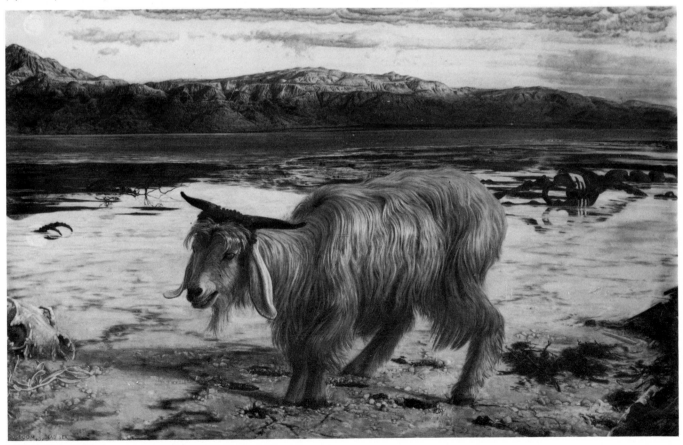

William Holman Hunt
The Scapegoat, 1854. Oil on canvas 33¾ × 54½ in.
(Courtesy of the Trustees of the Lady Lever Art Gallery, Port Sunlight)

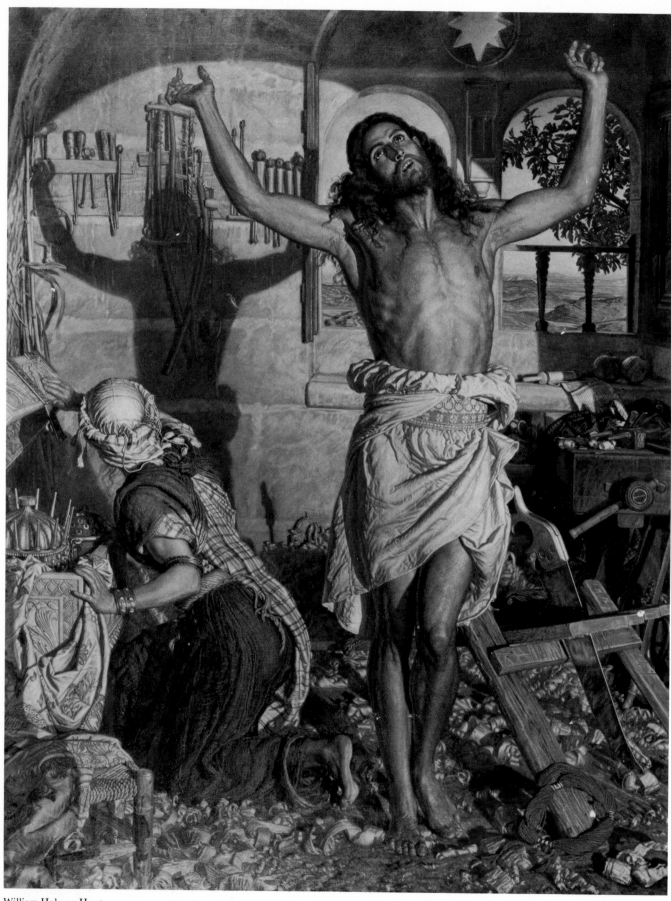

William Holman Hunt
The Shadow of Death, 1870–3. Oil on canvas 84⁵/₁₆ × 66³/₁₆ in.
(City of Manchester Art Galleries)

William Holman Hunt
Isabella and the Pot of Basil, 1867. Oil on canvas 72⅜ × 44½ in.
(Laing Art Gallery, Newcastle-upon-Tyne, Tyne and Wear County Council Museums)

DANTE GABRIEL ROSSETTI
1828–1882

Rossetti was Italian by origin on both sides of his family. He was steeped from his earliest years in the romance of Italian literature, notably the works of his great namesake, and brought up in an atmosphere of intrigue and revolutionary plots more befitting a fellow-conspirator of Manzini or Garibaldi than an English poet and painter. He was born in Bloomsbury, however, and rarely left London, let alone England, to explore the Europe of his heritage. His education, though ostensibly pursued at two London day schools was, in fact, conducted at the family fireside. His knowledge of languages and literature was consequently unusually wide.

Holman Hunt described him as having 'perhaps a greater acquaintance with the poetical literature of Europe than any other man'. This is obviously an exaggeration but pardonable amongst friends where the possession of a good formal education was a rarity. Millais is said to have spent only two days at school, the rest of his education being accomplished entirely by his mother.

The idea of an artistic secret society probably originated with Rossetti. Holman Hunt would have been satisfied with a type of discussion group in addition to a concerted assault on the Academy. In the event the idea of a secret society of young revolutionaries who considered themselves better than Raphael and his followers infuriated critics and public alike. Ironically, it was Rossetti's indiscretion which revealed the existence of this secret society. He had also undermined the solidarity of the P.R.B. by exhibiting his Pre-Raphaelite pictures in the so-called Free Exhibition at Hyde Park Corner instead of at the Royal Academy. In spite of this it was he who was to mourn with such obvious sincerity the dissolution of the group in 1853.

Rossetti's several attempts to learn to paint were, one after the other, abandoned as the terrible tedium of an accepted course of instruction became too much of a burden. Even his lessons with the greatly admired Madox Brown, and Holman Hunt, the new hero encountered in 1848, were only briefly compelling. From 1849 onwards he chose to make his own mistakes without the benefit of further lessons. Ruskin's correspondence with him during the 1850s is full of carefully considered technical advice, but in spite of this great variety of educational experience Rossetti never really mastered the mysteries of a painting technique that would have allowed him to express his ideas. Some of his difficulties with the course at Sass's Drawing School and at the Royal Academy Schools were undoubtedly caused by indolence. It is also worth recording, however, that throughout the whole of this period, and until 1848, he was still undecided whether to take up art or literature.

Shortly before the formation of the P.R.B. he wrote to Leigh Hunt seeking advice as to whether he should make painting or poetry his main occupation. It is in the knowledge of this preoccupation with another, equally demanding art form, that his achievement should be judged. In this light mere technical incompetence, when allied to such a powerful poetic imagination able to express itself either in verse or visually, becomes an unimportant issue. Possibly this lack of drawing facility saved him from the banalities of Millais' late style. Even if his later works do not appeal to modern taste they must at least escape the accusation of triviality and sentimentality which has, with

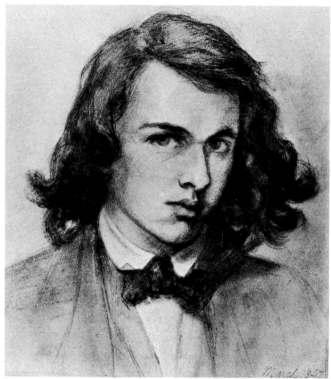

Dante Gabriel Rossetti
Self Portrait, aged 19, March 1847.
Pencil 7¾ × 7 in.
(National Portrait Gallery, London)

justification, been levelled at the popular art of the period.

It is greatly to the credit of Rossetti's family that they did not at any point try to lure him from his aesthetic occupations into more financially rewarding employment. This was logical in the case of Millais' artistic career since his family were wealthy and his talent was clearly prodigious, but Rossetti's situation was very different. Even if, unlike Holman Hunt's father, Rossetti's family had no commercial ambitions for their eldest son, it would not have been outrageous for them to have expected him to make some financial contribution in their declining fortunes.

In 1842 old Mr Rossetti's health began to fail and during the next ten years his prospects of employment as an Italian teacher diminished, finally rendering the financial situation acute. Rossetti's mother and sisters were compelled to seek employment as governesses and school mistresses. Rossetti's finances remained precarious throughout the whole of his career, and it fell to William Michael, his younger brother, to contribute to the support of the family. Therefore, it is not surprising to find a certain amount of information about the finances of all the P.R.B.'s in W. M. Rossetti's account of the Movement.

The extremes of financial privation were relieved for Rossetti in the 1850s by Ruskin, who undertook to buy all his pictures. Rossetti had cut himself off from the opportunity of selling his work through the Royal Academy by refusing to exhibit there from 1851 onwards. His work was thus rarely seen in public and was not widely known during his lifetime. A few pictures were shown in Liverpool, and six of his pictures at the Pre-Raphaelite exhibition in Russell Place in 1857. He declined to exhibit at the English Paintings show

Dante Gabriel Rossetti
Morning Music, 1864. Watercolour 11⅝ × 10½ in.
(The Fitzwilliam Museum, Cambridge)

held in New York in the same year. His work sold mainly to wealthy patrons, many of them Northern industrialists who were content to accept unquestioningly Ruskin's valuation of his work.

These men were to have their tolerance of the artistic temperament stretched to its fullest extent. For example, Mr MacCracken, a Belfast packing agent, commissioned from Rossetti, (at the artist's suggestion) the ill-fated *Found*. He already owned *Ecce Ancilla Domini* (Rossetti wrote at the time of the sale 'I have got rid of my white picture to an Irish maniac'), and was later to buy *Dante Drawing an Angel on the First Anniversary of the Death of Beatrice*. Therefore he was anxious to own this important subject from modern life. After waiting twelve months for the picture to be started MacCracken must have lost heart, and the picture had to be re-commissioned in 1859 by James Leathart, another valuable patron who had bought Madox Brown's *The Pretty Baa-Lambs* and a replica of *Work*. Even Leathart was not the last patron to be associated with *Found*. In 1869 William Graham of Glasgow was persuaded to re-commission it. He was, understandably, impatient by 1879 but was reassured by Rossetti that work on the picture was proceeding. He did, in fact, continue to work on it until his death in 1882, when, still unfinished, it was claimed by Graham. Although no other commissions caused such trouble as this intractable subject, Rossetti was certainly a difficult artist for his patrons. It must be taken as a measure of his artistic genius that these hard-headed businessmen persisted in acquiring his works.

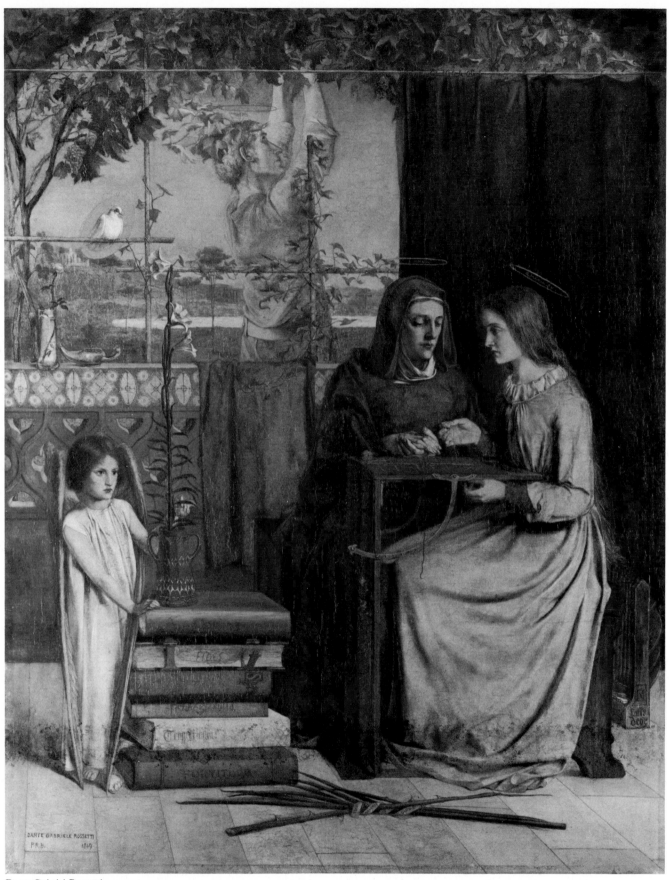

Dante Gabriel Rossetti
The Girlhood of Mary, 1848–9. Oil on canvas 32¾ × 25¾ in.
(The Tate Gallery, London)

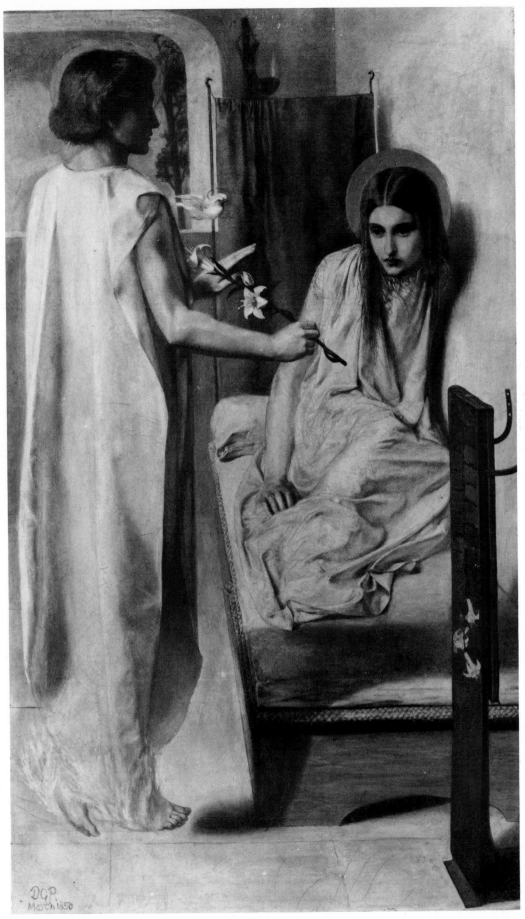

Dante Gabriel Rossetti
Ecce Ancilla Domini (The Annunciation), 1849–50. Oil on canvas 28½ × 16½ in.
(The Tate Gallery, London)

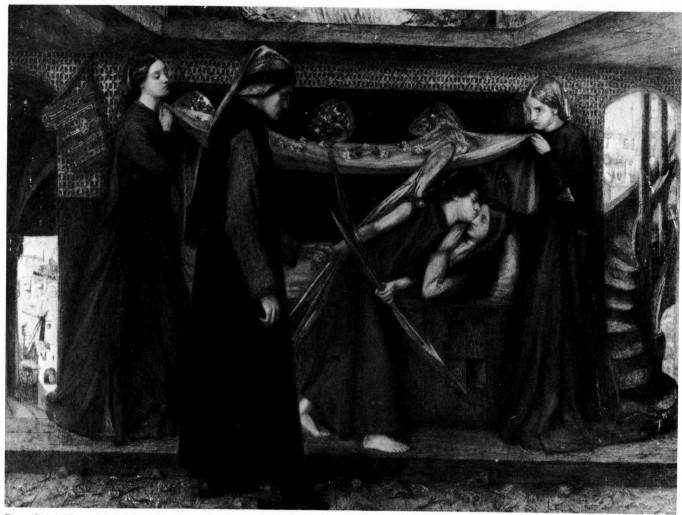

Dante Gabriel Rossetti
Dante's Dream at the Time of the Death of Beatrice, 1856. Watercolour 18½ × 25¾ in.
(The Tate Gallery, London)

Dante Gabriel Rossetti
Salutatio Beatricis (Meetings of Dante and Beatrice), 1859. Oil on panel. Each panel 29¼ × 31½ in.
(The National Gallery of Canada, Ottawa)

66

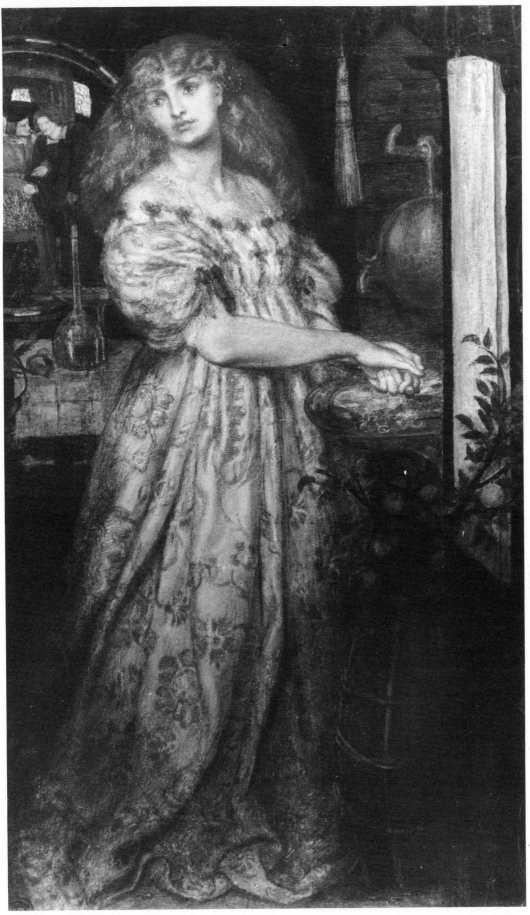

Dante Gabriel Rossetti
Lucretia Borgia, c.1858–83. Watercolour 16½ × 9½ in.
(The Tate Gallery, London)

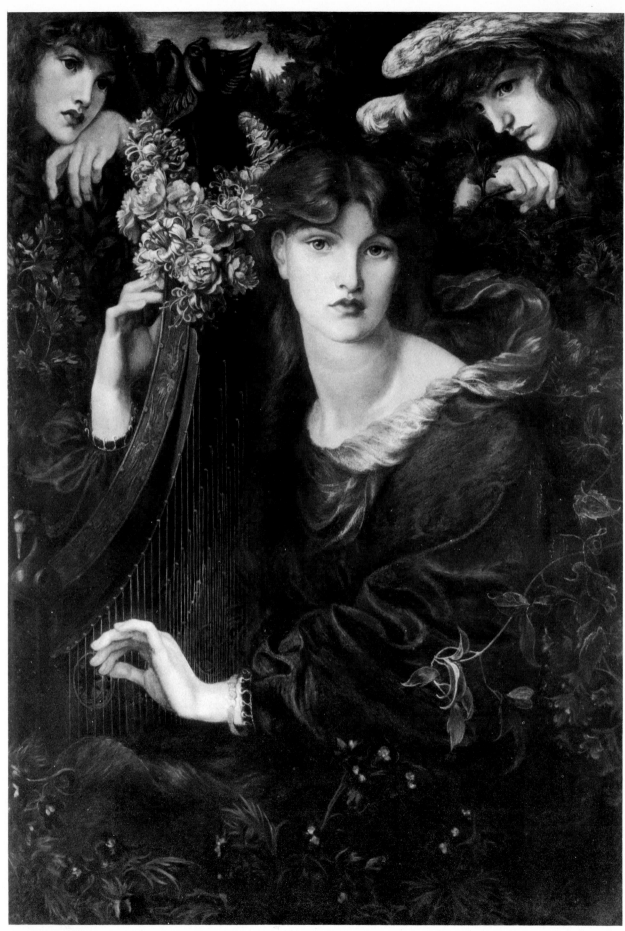

Dante Gabriel Rossetti
La Ghirlandata, 1873. Oil on canvas 45½ × 34½ in.
(Guildhall Art Gallery, London)

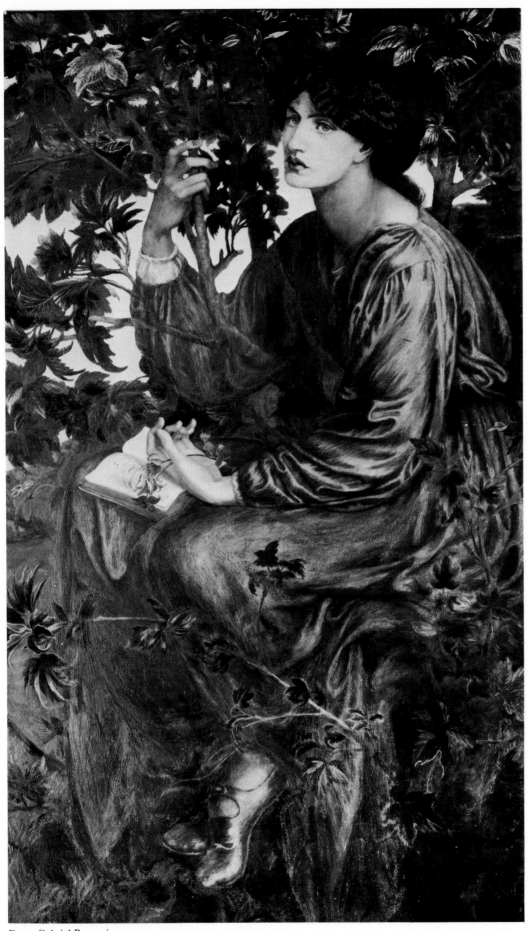

Dante Gabriel Rossetti
The Day-Dream, 1880. Oil on canvas 62½ × 36½ in.
(Victoria and Albert Museum, London)

SIR JOHN EVERETT MILLAIS P.R.A.

1829–1896

Millais was a child-prodigy of such exceptional promise that he was admitted to the Royal Academy Schools at the age of eleven. Ruskin records an anecdote of his youthful talent which suggests that he could draw with complete adult assurance at the age of seven. Unlike most other aspiring painters he was given every encouragement in the pursuit of his chosen career, his parents even moving from their home in Jersey to allow him to study in London. His amazing facility of hand and eye, coupled with the most thorough and vigorous training available, allowed him to accomplish astonishing feats of technical proficiency. He maintained a consistently high degree of accurate representation, for which he was accorded the unstinted admiration of the public.

Millais was awarded a baronetcy, elected President of the Royal Academy and enjoyed, at the height of his success, an income of £30,000 per year. The interior of his large house in Palace Gate is a testimony to his achievement, furnished with an opulence which contrasts strangely with the aesthetic Morris-inspired schemes favoured by Rossetti and Burne-Jones. Ironically all this adulation was accorded to Millais' later works when the demands of his growing family, and probably also of his own temperament, had led him to abandon Pre-Raphaelitism in favour of portrait painting (he became one of the most successful English portrait painters of the age) and of popular historical and genre subjects.

The contrast between his Pre-Raphaelite paintings and his later works shows with startling clarity how greatly Pre-Raphaelitism must have offended popular taste. The comparison can be made directly in at least one instance, between the dream-like *The Bridesmaid* of 1851, and the same subject dating from 1879, which is a conventional portrait treatment of his second daughter Mary as bridesmaid to her older sister. Millais himself had foreseen this situation early on, and is recorded as advising intending purchasers to buy his pictures while he was still working for fame rather than for a wife and children. It can surely be no coincidence that Millais' change in style occurs almost precisely at the time of his marriage. Ruskin was appalled by Millais' 1857 Academy picture *A Dream of the Past: Sir Isumbras at the Ford*, and the end of his Pre-Raphaelite phase is usually dated in 1855 or '56. Modern taste has sided with Ruskin in admiring the earlier works, and it seems unlikely that *The Boyhood of Raleigh* or *Bubbles* will again eclipse *Christ in the House of his Parents* or *The Blind Girl* in popular esteem.

Millais came from a Jersey family, but was born in Southampton. He lived in Jersey until he entered Sass's Drawing School at the early age of nine. Two years later he entered the Royal Academy Schools where he stayed for six years. His remarkable *Pizarro seizing the Inca of Peru,* painted when he was only sixteen, was exhibited at the Academy in 1846. Before the formation of the P.R.B. Millais had already completed and exhibited a number of pictures, stylistically typical of his period, following Etty or Maclise, in what Hunt refers to as 'the old style' when speaking of the pictures that Millais still had not completed when he embarked on his first Pre-Raphaelite work. *Lorenzo and Isabella* illustrates an incident from Keat's poem *Isabella, or the Pot of Basil.* It was shown at the Academy in 1849 and received sufficiently encouraging notices for Millais to feel that Pre-Raphaelitism

had a good chance of success.

In the following year these sanguine hopes were shattered with the abusive reception of the new Pre-Raphaelite pictures, including Millais' *Christ in the House of his Parents.* It was possibly the accusation of blasphemy against this work which prompted Collinson to withdraw from the P.R.B. Further critical attacks followed in 1851, Millais being abused particularly for the commonplace appearance of the left-hand figure in *The Return of the Dove to the Ark.* At this point Ruskin was persuaded to intervene and the worst criticisms of the Pre-Raphaelite work gave place to temperate enthusiasm. By 1852 Millais' *The Huguenot* gained a great popular success at the Academy, and in 1853 he was elected an A.R.A. Rossetti regarded this defection to the establishment as marking the end of Millais' association with the Pre-Raphaelites.

Few Pre-Raphaelite works followed *The Huguenot. The Blind Girl* and *Autumn Leaves* were completed by 1856 and shown at the Academy in that year. The years between 1857 and 1870, when the first of the popular subject-pictures, *The Boyhood of Raleigh* was painted, were occupied with a mixture of literary, historical and genre pictures. Some of these enjoyed considerable popular success, for example *The Black Brunswicker* and the two *Sermon* pictures. From 1870 the subject pictures were interspersed with highly successful society portraits painted with great fluency and accuracy. They present a sad contrast to the originality and intensity of vision in, for example, the early portraits of Millais' patron *James Wyatt* and his daughter *Mrs James Wyatt junior* painted in 1849, or the *Wilkie Collins* of 1850 and *Mrs Coventry Patmore,* 1851, but they were precisely what the sitters required and expected.

In 1886, the year after he had been created a Baronet, one hundred and fifty-nine of Millais' works were shown at an exhibition in the Grosvenor Gallery, and Holman Hunt claims that Millais then recognised the decline in quality of his later works, admitting to an acquaintance that 'I'm not ashamed of avowing that I have so far failed in my maturity to fulfil the full forecast of my youth'.

Millais would have probably developed as an academic painter much earlier had it not been for his friendship with Holman Hunt. For him Pre-Raphaelitism was simply an episode, which provided an opportunity to experiment with techniques and compositional effects outside the usual range of a successful and popular artist, and to test critical reaction to the new and unusual. It is unlikely that his true temperament was drastically altered by his marriage, therefore it must be assumed that the academic painter was in abeyance while the Pre-Raphaelite took over, ready to emerge when required.

Opposite
John Everett Millais
The Woodman's Daughter, 1851.
Oil on canvas 35 × 25½ in.
(Guildhall Art Gallery, City of London)

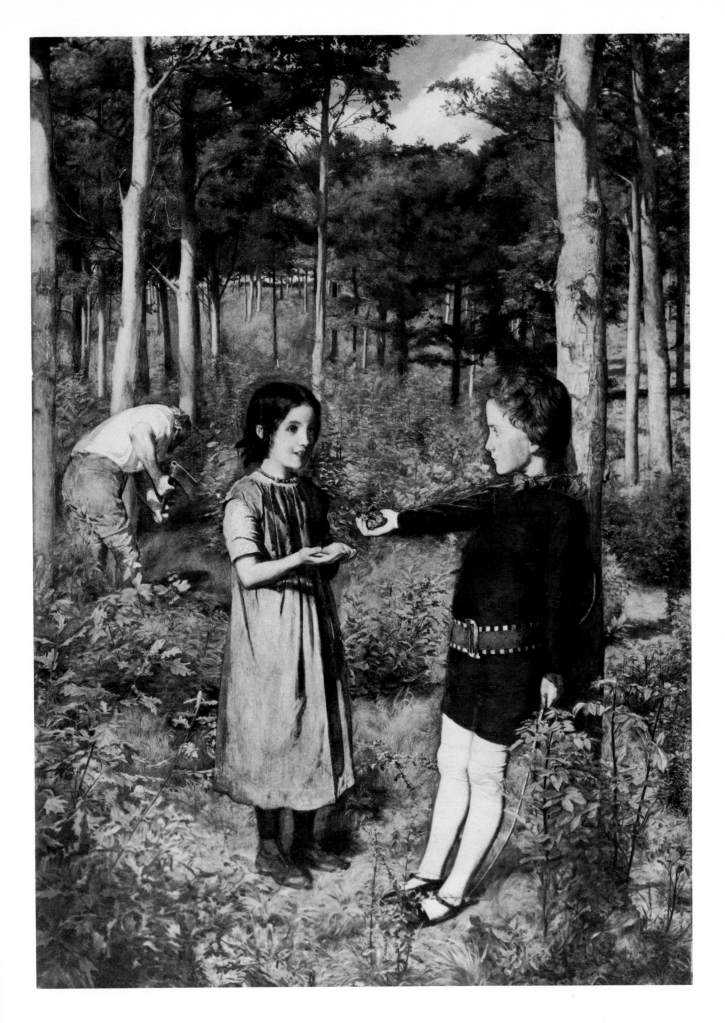

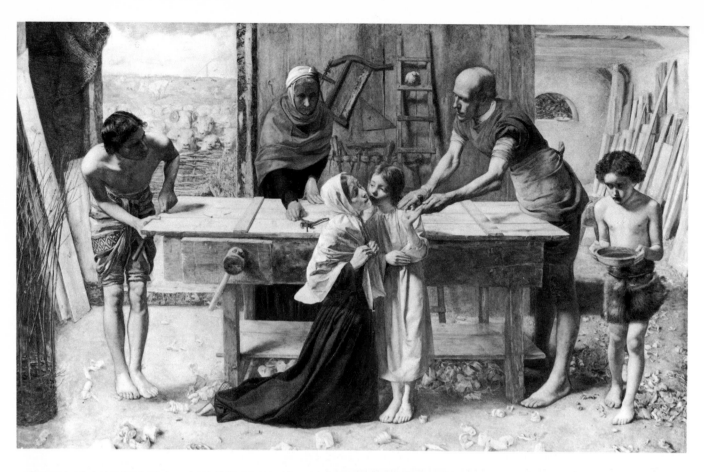

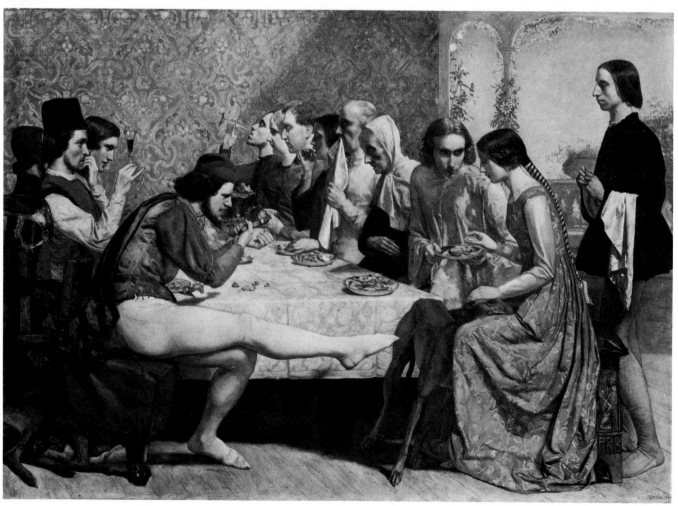

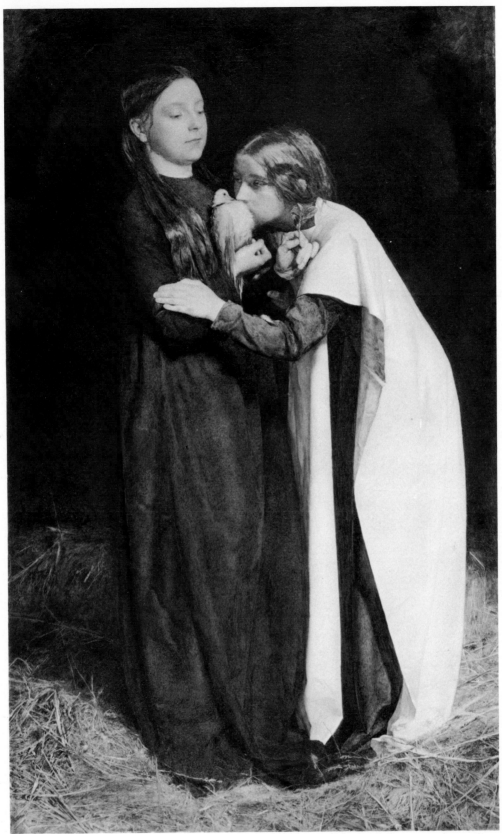

Opposite above
John Everett Millais
Christ in the House of His Parents (The Carpenter's Shop), 1849–50.
Oil on canvas 34 × 55 in.
(The Tate Gallery, London)

Opposite below
John Everett Millais
Lorenzo and Isabella, 1849.
Oil on canvas 40½ × 56¼ in.
(The Walker Art Gallery, Liverpool)

Above
John Everett Millais
The Return of the Dove to the Ark, 1851.
Oil on canvas 34½ × 21½ in.
(Ashmolean Museum, Oxford)

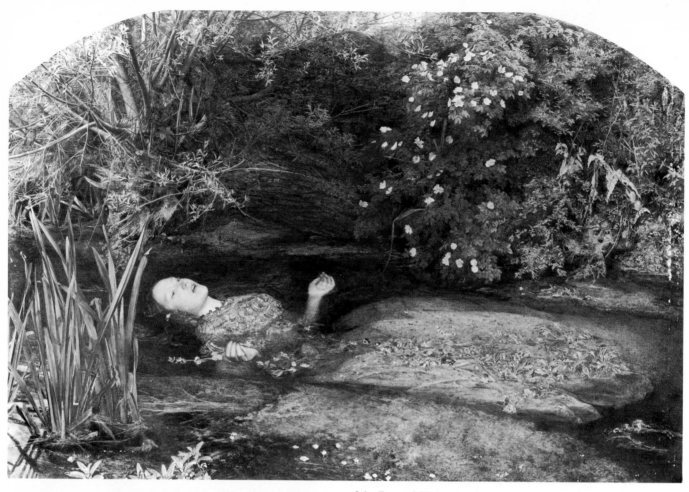

John Everett Millais
Ophelia, 1851–2.
Oil on canvas 30 × 44 in.
(The Tate Gallery, London)

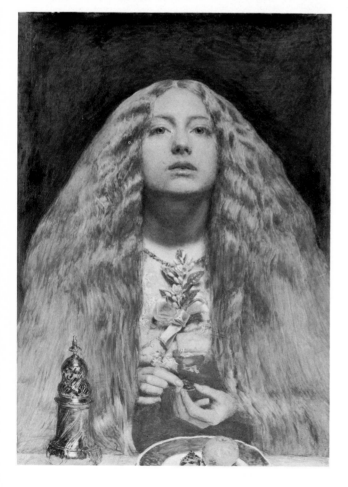

John Everett Millais
The Bridesmaid, 1851.
Oil on wood 11 × 8 in.
(Fitzwilliam Museum, Cambridge)

Opposite
John Everett Millais
The Blind Girl, 1854–6.
Oil on canvas 32 × 24½ in.
(By courtesy of Birmingham Museums and Art Gallery)

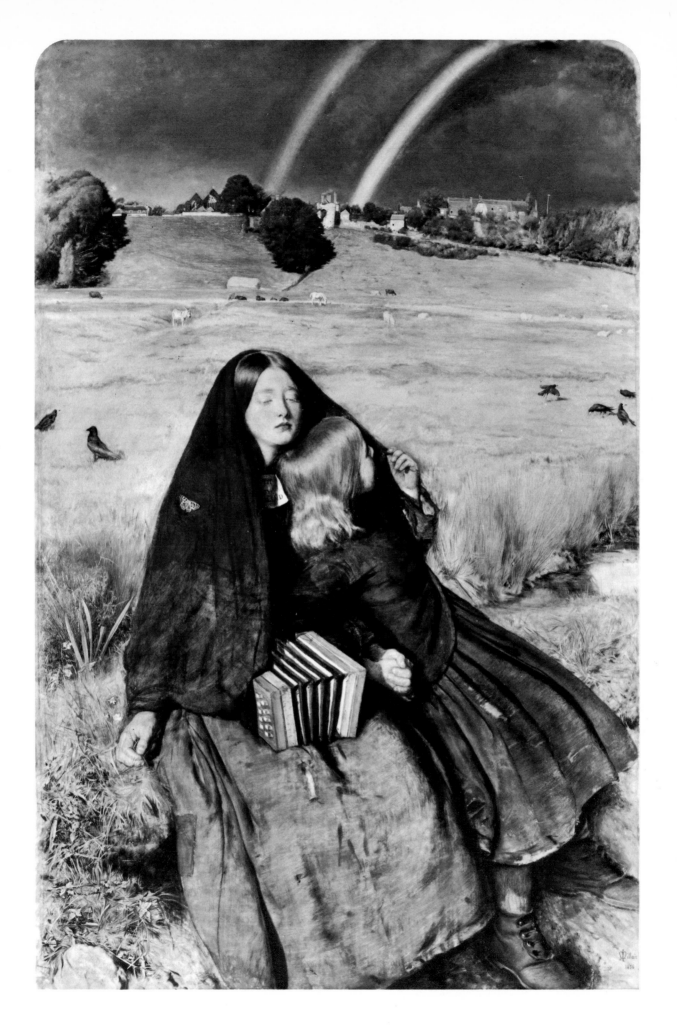

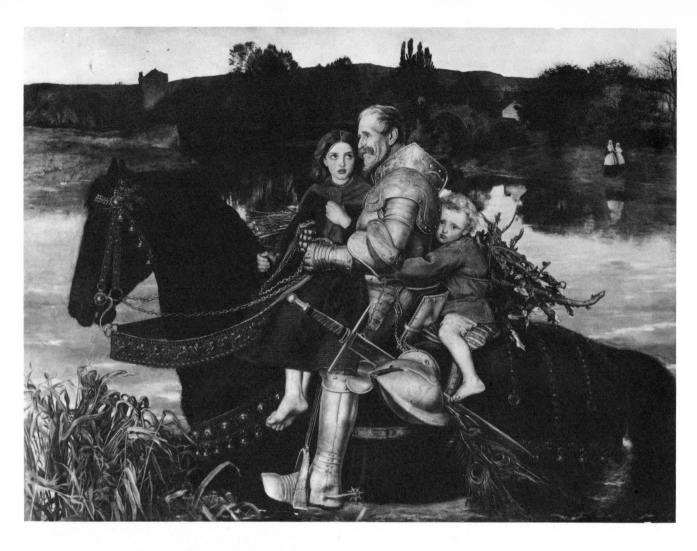

John Everett Millais
A Dream of the Past: Sir Isumbras at the Ford, 1856–7.
Oil on canvas 49 × 67 in.
(Courtesy of the Trustees of the Lady Lever Art Gallery, Port Sunlight)

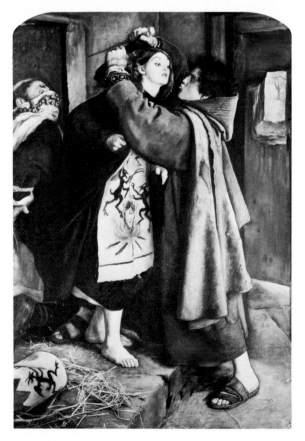

John Everett Millais
The Escape of a Heretic, 1857.
Oil on canvas 42 × 30 in.
(Museo de Arte de Ponce, Puerto Rico. Luis A. Ferré Foundation)

Opposite
John Everett Millais
Autumn Leaves, 1855–6. Oil on canvas 41 × 29⅛ in.
(City of Manchester Art Galleries)

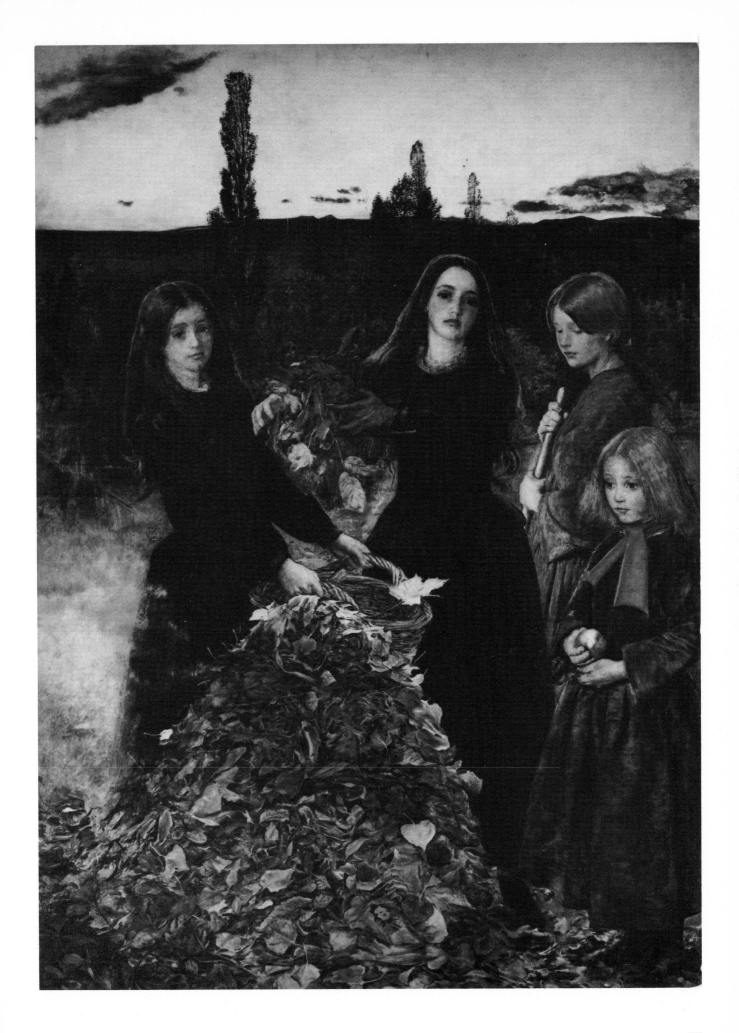

ARTHUR HUGHES
1832–1915

The works of Arthur Hughes present a paradox in being, at the same time, both amongst the best known and the least known of the Pre-Raphaelite paintings. There can be few people interested in the period who are not familiar with *April Love, Ophelia, The Long Engagement* and *Home from Sea*, as these are among the most frequently reproduced Victorian paintings. On the other hand, with few exceptions — including possibly *The Eve of St. Agnes, The Rift within the Lute, The Tryst* and the *Convent Boat* — his other works are hardly known even to those interested in the Pre-Raphaelite movement. An exhibition devoted to Hughes in 1971, and the appearance in the salerooms of a number of his later works, has gone some way to changing this state of affairs, but while these other paintings of his may now be known to a larger public, this has done little to alter his status as an artist and nothing to displace his best known works from their rightful niche among the most important of the Pre-Raphaelite pictures. There is really no comparison aesthetically between *April Love* and *Silver and Gold*, the first one painted at the high point of Hughes' involvement with the Pre-Raphaelite movement and the other nearly ten years later when his Pre-Raphaelite phase was already over. The similarity between the *Convent Boat*, which was completed over twenty years after Hughes' first contact with the members of the Brotherhood, and Millais' *The Vale of Rest* is deceptive and misleading. Hughes' picture is too unequivocally anecdotal to be admitted to the canon, in which even the inclusion of *The Vale of Rest* is sometimes the subject of dispute.

Although in his later pictures Hughes can be seen to descend from the gentle *tristesse* of *April Love* and *The Long Engagement* into the banal sentimentality of *Memories* or *The Adoration of the Shepherds and the Kings*, one of his last pictures painted in 1902, his graphic work retained all the qualities of the early paintings throughout the 1860s. The illustrations to the fairy tales of George Macdonald, *At the Back of the North Wind, The Princess and the Goblin*, and *The Princess and Curdie*, as well as those for Christina Rossetti's book of children's poems, *Sing Song* (which appeared in 1872 and for which Hughes made a hundred and twenty-five drawings), were all done in the late 1860s and early 1870s, and the drawings for this purpose retain much of the charm of the earlier works right up to the end of Hughes' life.

Hughes was born in London on the 27th January, 1832. In 1846 he entered the School of Design at Somerset House where he studied under Alfred Stevens. In 1847 he went on to the Royal Academy Schools where he won a silver medal for Antique drawing two years later. In that same year (1849) he exhibited for the first time at the Royal Academy, showing a conventional figure subject in the accepted academic taste of the period entitled *Musidora* (now in the Birmingham Art Gallery). The following year was to prove the most important of his life when he made the contacts which were to have far-reaching consequences on his work and his manner of living. It was in 1850 that he first met Miss Tryphena Foord who was later to become his wife (they married in 1855 and had three daughters and two sons) and who was presumably the principal architect of the happy and hermetic family existence which encouraged Hughes to retire in 1858 to the suburbs, thus breaking away from the society of his fellow artists and submerging himself from public view until his death at an advanced age in 1915. In 1850 he also saw a copy of the short-lived Pre-Raphaelite magazine *The Germ*, and was so impressed with the work of those involved that he overcame his natural reticence enough to seek the acquaintance of Holman Hunt, Rossetti and Madox Brown. It is possible to see the results of this epic-making contact in every aspect of Hughes' early work. Curiously enough he did not meet Millais, with whom his own work is most closely linked, until varnishing day at the Academy in 1852. His earliest Pre-Raphaelite work, *Ophelia*, which was exhibited at the Academy in 1852, as was Millais' own version of the same subject, is very different from the Millais-influenced *Ferdinand Lured by Ariel, April Love* or *The Tryst*, particularly in the suggestion of a deep but ill-defined space in the background. In the following year he began painting *The Long Engagement*, painting the forest scene directly from nature in the accepted Pre-Raphaelite manner. *The Tryst* was started in 1854, *April Love* in 1855 and *The Eve of St. Agnes* in the following year. *Home from Sea* was started in 1857 but not completed until 1863, when Hughes' Pre-Raphaelitism had already given way to the softer, less confined vision of the later works. The last of the Pre-Raphaelite pictures, it might be claimed, are *The Woodman's Child* (exhibited at the Royal Academy in 1861) and *Home from Work*, followed by an intense Arthurian subject, *The Knight of the Sun*.

The year before he retreated to the suburbs Hughes was involved with Rossetti and John Hungerford Pollen in the ill-fated mural decorations at the Oxford Union. Later, in 1862, he did a design for a stained glass panel for Morris and Company, but his involvement with the commercial ventures which kept a form of Pre-Raphaelitism alive at least until Morris's death in 1896 were, with the exception of the illustrative work, almost totally minimal. From the end of the 1860s he embraced the obscurity which was to surround his later work until the present day.

Opposite
Arthur Hughes
Fair Rosamund, 1854.
Oil on board 39.7 cm. × 26.7 cm.
(National Gallery of Victoria, Melbourne; Presented by Miss E. H. Gilchrist in memory of Mr. P. A. Daniel)

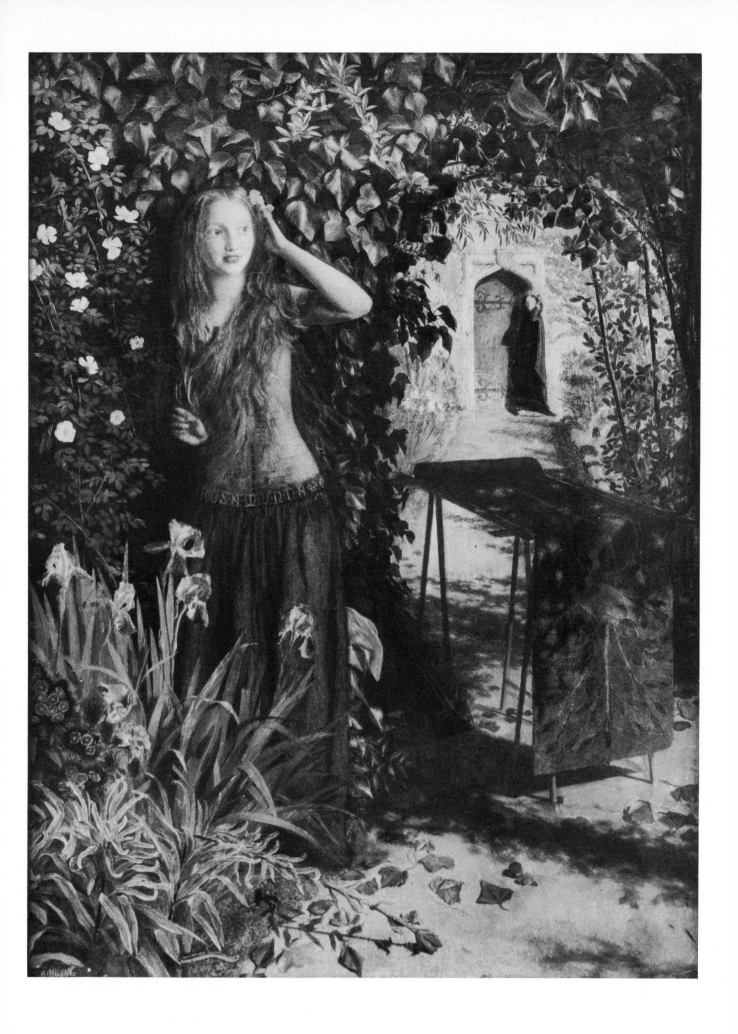

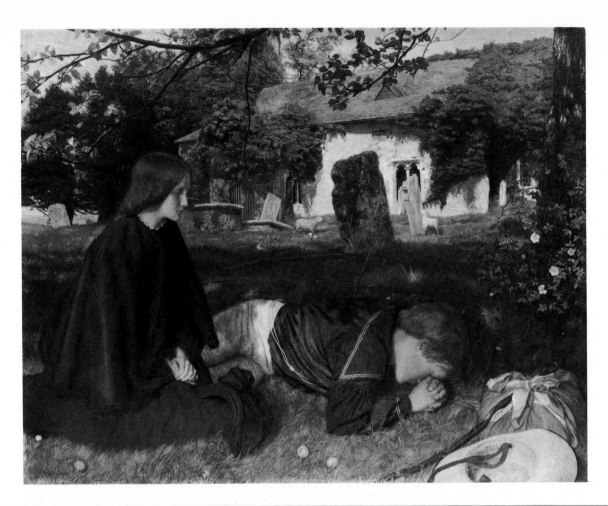

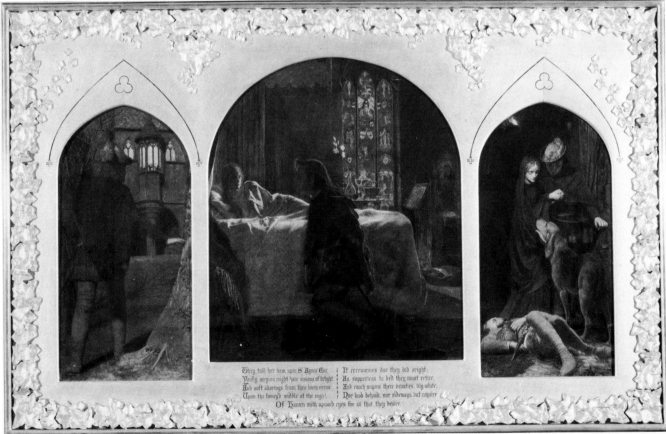

Arthur Hughes
The Eve of St. Agnes, 1856.
Triptych, oil on canvas, centre 25½ × 22¼ in; sides, each 23¼ × 11¾ in.
(The Tate Gallery, London)

Arthur Hughes
Home from Sea, 1856–63.
Oil on panel 20 × 25¾ in.
(Ashmolean Museum, Oxford)

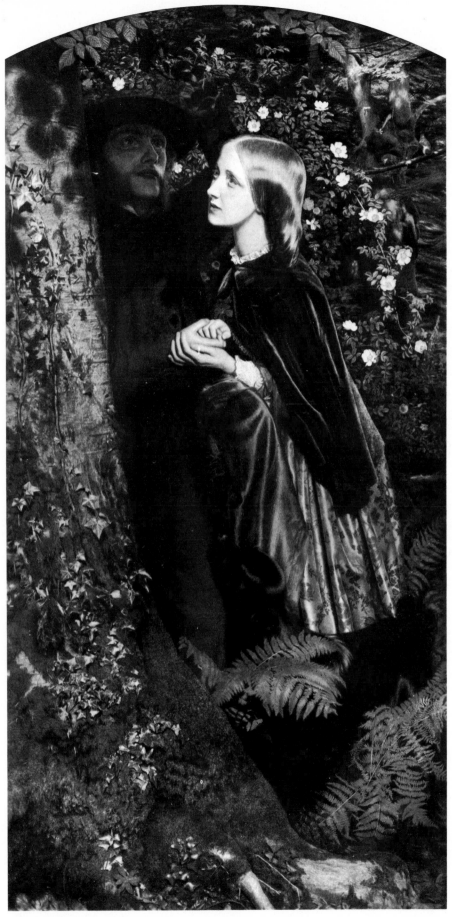

Arthur Hughes
The Long Engagement, 1853–9. Oil on canvas 41½ × 20½ in.
(By courtesy of Birmingham Museums and Art Gallery)

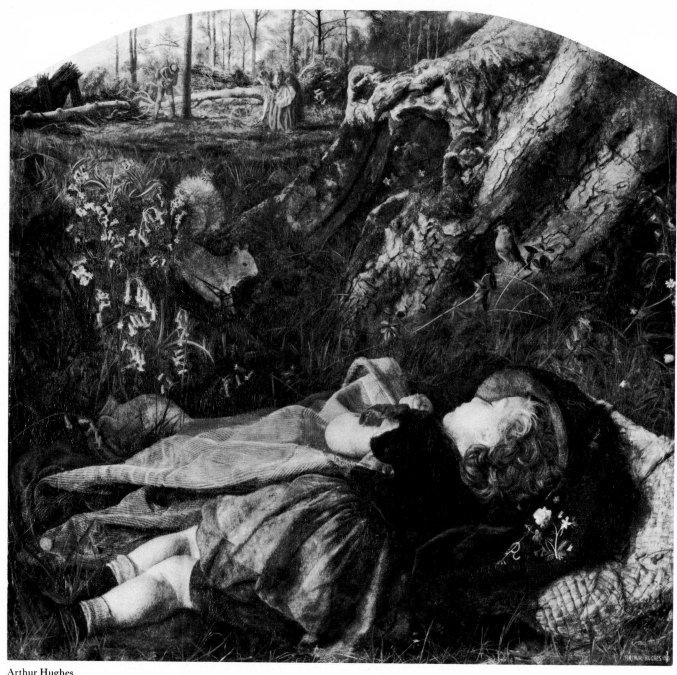

Arthur Hughes
The Woodman's Child, 1860. Oil on canvas 24 × 25¼ in.
(The Tate Gallery, London)

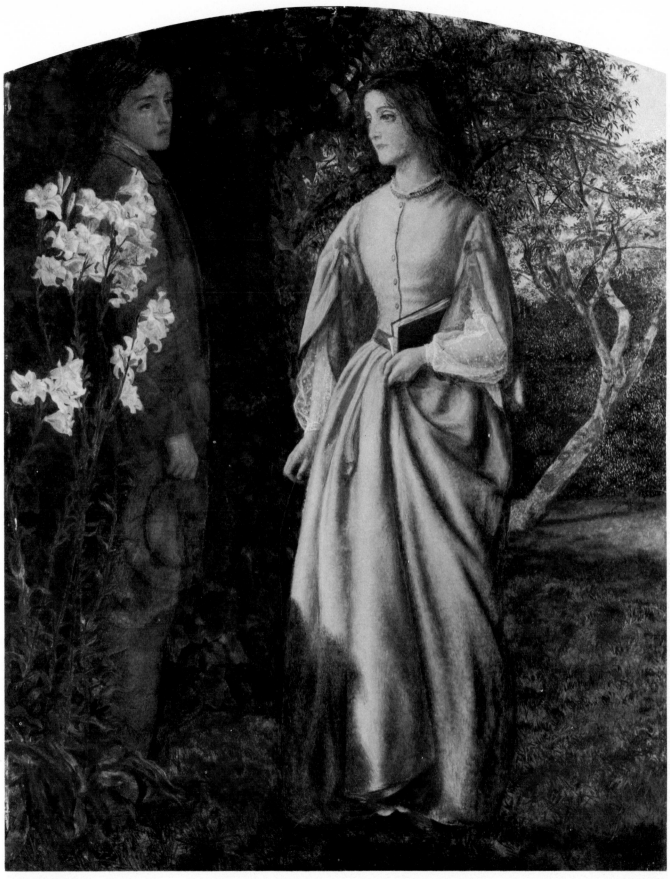

Arthur Hughes
Aurora Leigh's Dismissal of Romney (The Tryst), 1860. Oil on panel 15¼ × 12 in.
(The Tate Gallery, London)

HENRY WALLIS
1830–1916

Wallis was unusual in the Pre-Raphaelite circle in having spent a period at the Ecole des Beaux-Arts in Paris in addition to his time at the Academy Schools. He also worked in the *atelier* of Gleyre, an experience later shared by Whistler and a number of the Impressionist painters. No trace of this training is apparent in Wallis' painting. It is indeed rare to find any signs of continental influence in Pre-Raphaelite works even in the few instances where the artists sought experience abroad (*cf.* Thomas Seddon).

Little is known of Wallis due to a conspiracy of silence which followed his elopement with George Meredith's wife in 1858, and few of his paintings have come to light. A considerable number of drawings from the artist's family have appeared on the market which suggest that he later concentrated mainly on landscape. Some were done in the East, a period of residence abroad frequently being the penance exacted from adulterous couples by Victorian society.

Wallis exhibited in London for the first time in 1854. In 1856 his death of *Chatterton* created a mild sensation and in 1858 *The Stonebreaker* was described by Ruskin as 'the picture of the year; but narrowly missing being a first-rate of any year'. The young George Meredith was the model for *Chatterton*, which was painted in the very attic in Gray's Inn where the poet died. This and *The Stonebreaker* seem to have been the most Pre-Raphaelite of Wallis' surviving works. *The Sculptor's Workshop* is more in the tradition of the Victorian historical painting, with its accurate costume and anecdotal detail.

Wallis was made an associate member of the Old Watercolour Society in 1878 and a full member two years later. He continued to exhibit at the Royal Academy until 1893, but during his extensive travels became interested in Egyptian and Etruscan antiquities, and in ceramics, which he studied with the eye of an artist rather than the scientific zeal of an archaeologist. His main interest was in ancient pottery, mediaeval tiles, majolica and hispano-moresque wares. Between 1885 and 1911 he published over twenty studies of these subjects, all but one or two extensively illustrated by himself. When Wallis died in 1916 Albert van der Put published an appreciation of his contribution to ceramic studies accompanied by an invaluable bibliography. Wallis' notebooks containing notes and preparatory sketches, now in the Victoria and Albert Museum, bear witness to the value of the Pre-Raphaelite visual training which demanded such an eye for detail.

Henry Wallis
Chatterton, 1856. Oil on canvas 24½ × 36¾ in.
(The Tate Gallery, London)

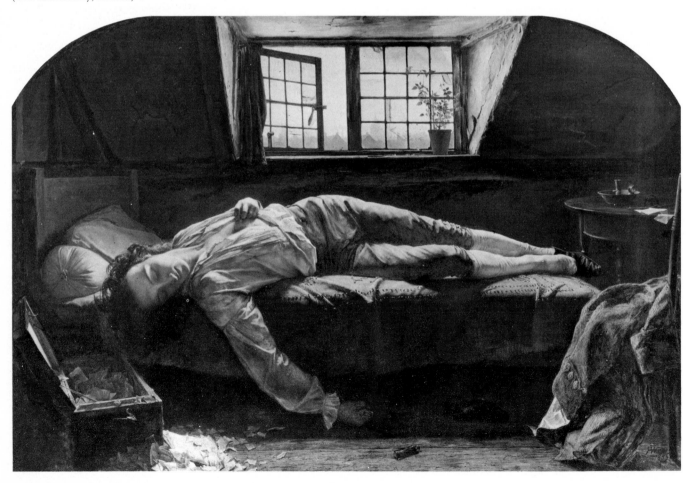

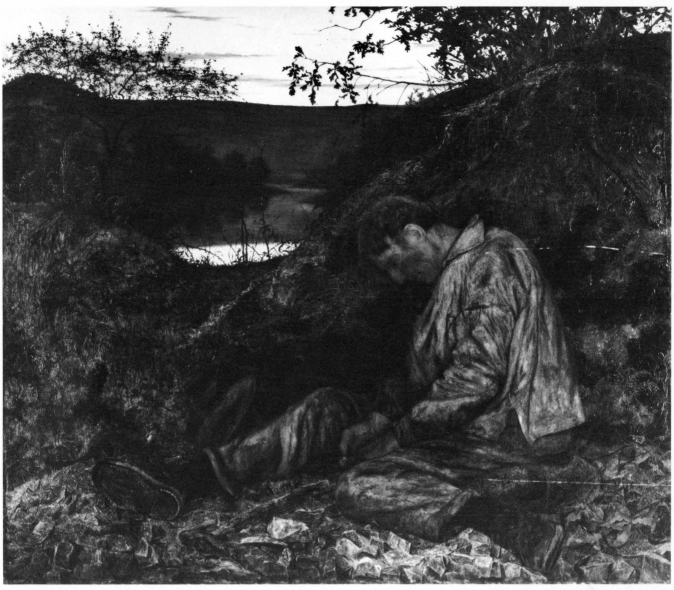

Henry Wallis
The Stonebreaker, 1857. Oil on panel 25¾ × 31 in.
(By courtesy of Birmingham Museums and Art Gallery)

JOHN WILLIAM INCHBOLD
1830–1888

Although Inchbold is regarded as the leading talent amongst the Pre-Raphaelite landscape painters, little is known of him apart from his work. He was born in Leeds, the son of the proprietor of the *Leeds Intelligencer,* and was said to be 'of a sensitive and retiring disposition'. He went to the Royal Academy Schools in 1847, having already studied drawing in Leeds as a boy. He had also spent some time learning lithography with the firm of Day and Haghe. He first exhibited in 1849 with the Society of British Artists and then at the Academy in 1851. The works of these early years, where they have been traced, are atmospheric water colours with no hint of Pre-Raphaelitism in their broad handling. By 1852, however, a considerable change must have taken place. William Michael Rossetti compared his Academy exhibit, entitled simply *A Study,* with the work of the landscapist William Millais and the lost *May in Regent's Park* by C. A. Collins, citing it as an example of the spread of Pre-Raphaelitism in landscape painting.

Inchbold came to know the Rossettis and seems to have been a source of considerable irritation to D. G. Rossetti. This contact, however, is not reflected in his work, his Pre-Raphaelite pictures being Ruskinian in conception and execution. In *The Chapel, Bolton,* exhibited at the Academy in 1853, a Wordsworth subject (taken from *The White Doe of Rylstone*) is used as an excuse for a minutely observed study of crumbling stone and encroaching vegetation, with a landscape beyond seen through an arch. The white doe which is delicately poised in the foreground seems incidental to the composition, in contrast to Holman Hunt's sheep — heavy with moral significance — perched on the cliffs in *Our English Coasts (Strayed Sheep)*. In 1854 Millais saw the rejected *Anstey's Cove, Devon* when Inchbold submitted it to the Academy and he wrote to Hunt remarking on this difference, describing it as 'not in the least like yours' (referring to *Our English Coasts* which had been exhibited at the same time as *The Chapel, Bolton*).

In 1854 Inchbold's work also came to the notice of Ruskin. For three summers they spent some time in Switzerland, Inchbold being subjected to the same course of exhortation and instruction that was later to fall to the lot of John Brett. Ruskin's writings reveal that Inchbold, like Brett, failed to reach the hoped for standards. By the third year Ruskin had clearly lost interest in his protegé and his energies were now consumed by urging Brett to greater efforts regarding the painting of the *Val d'Aosta*.

The quality of Inchbold's later work is mainly disappointing, but he is remarkable amongst the Pre-Raphaelites for having produced, in the late 1860s, a series of landscape oil sketches which — apart from their colour — can be compared with the work of earlier *plein-air* painters in their bold semi-abstract handling. Even the small sketch of *Tintagel-Cornwall,* painted in 1862/3, far outstrips, in its broadness of vision, any landscape study that the others produced, while the later sketches show that Inchbold was able to work outside the cramped, two-dimensional conventions of Pre-Raphaelite composition.

John William Inchbold
At Bolton (The White Doe of Rylstone), 1855.
Oil on canvas 27 × 20 in.
(Leeds City Art Galleries)

JOHN BRETT
1831–1902

In most studies of the Pre-Raphaelite movement Brett is distinguished by the assertion that he was at once both made and destroyed by Ruskin. It is often said that his great labour over the *Val d'Aosta*, painted under Ruskin's direction during five months in 1858, exhausted his capacity for poetic feeling and left him obsessed with the minute observation of detail. It is clear from his extensive notes on the picture that Ruskin himself shared this view. Although Ruskin bought the painting, for which he must have felt responsible, he made an abortive attempt to sell it quite shortly afterwards. In fact Brett's most Ruskinian work, *The Glacier at Rosenlaui* (1856), was painted before he came into contact with the great man, and was only indirectly influenced by Ruskin, being the result of a meeting with J. W. Inchbold in Switzerland in 1856.

Brett was born in Surrey, the son of an Army officer. In 1854, at the relatively advanced age of 23, he entered the Royal Academy, after having studied for a period in Dublin where his father was stationed. In 1856 he first exhibited three portraits at the Academy. These seemed to indicate a decision to specialise in this field, but the trip to Switzerland and the momentous meeting with Inchbold were to alter his course. He 'there and then saw that I had never painted in my life, but only fooled and slopped, and thence forward attempted in a reasonable way to paint all I could see'. Two pictures dating from the following two years, *The Stonebreaker* (1856–8) and the *Val d'Aosta* demonstrate the extent to which he achieved this aim.

Brett's romanticism is particularly apparent in the social implications of *The Stonebreaker*. Ostensibly a protest against the exploitation of child labour, the idyllic weather and the beauty of the landscape contrive to make the young boy working at his task an enviable figure, with whom any schoolboy confined to the classroom would gladly have changed places. It is instructive to compare this painting with Wallis's treatment of the same subject. In the *Val d'Aosta* the romantic element is diminished. Instead, Ruskin's geological and meteorological interests become the central inspiration for the picture. It is impossible to say whether the next two years saw a drastic diminution in Brett's pictorial imagination as the works exhibited in 1869 *(The Hedger)* and 1861 *(Warwick Castle)* have both disappeared. The ambitious *Florence from Bellosguardo* (1863), the ravishing *Morant's Court in May* (1864) and the Neapolitan paintings dating from the mid-1860s have a lyrical quality in the observation of the effects of sunlight which was destroyed in the over-working of the geological detail of the *Val d'Aosta*.

By the mid-1870s the romantic inspiration and the capacity for complex pictorial organisation which produced the tour de force of the view of Florence seems to have been exhausted. The numerous later sea-coast pictures, many of Cornwall, are repetitive in composition and boring in execution. It would be unjust, however, to regard Brett (as Ruskin did) as a promising instrument which failed to come up to expectations when put to use.

John Brett
Lady with a Dove: Madame Loeser, 1864.
Oil on canvas 24 × 18 in.
(The Tate Gallery, London)

SIR EDWARD BURNE-JONES
1833–1898

Burne-Jones, who saw himself as a follower of Cardinal Newman, was destined for the Church from the age of fifteen. Instead he became a late recruit to Pre-Raphaelitism as the result of seeing the work of Rossetti in the collection of Thomas Coombe, Director of the Clarendon Press in Oxford, in 1855. Burne-Jones had already encountered the work of other members of the P.R.B. — Millais' *The Return of the Dove to the Ark*, and Holman Hunt's *The Awakening Conscience* and *The Light of the World* — in the previous year, but the visit to Thomas Coombe with his friend Morris confirmed his decision to abandon the priesthood and his career at Oxford in favour of painting. Early in 1856 he met Ruskin and Rossetti and managed to persuade the latter to accept him as a pupil, and in May he and Morris settled in Rossetti's old rooms at 17 Red Lion Square to begin their new lives in art.

Burne-Jones was an immensely hard worker and, in consequence, a very prolific artist. His Pre-Raphaelite works, executed under the influence of Rossetti, form a relatively small part of his total *oeuvre*. He is variously identified by Robin Ironside (*Horizon*, June 1940) as a romantic, a symbolist and an aesthete, and seen as part of the mainstream of European Symbolism with Gustave Moreau and Puvis de Chavannes. His Rossettian phase is dismissed as an attack of 'Pre-Raphaelite measles'. Nevertheless, the influence of Rossetti was ultimately crucial to the development of Burne-Jones's poetic imagination. His early works, painted either under the personal guidance of his master from similar mediaeval and literary sources, or resulting from Burne-Jones' own fascination with Giorgione and fifteenth century Florentine art in general are a valuable contribution to Pre-Raphaelitism.

Burne-Jones was born in Birmingham, the son of the owner of a small framing and gilding business. His mother died within a week of his birth and his family was poor. He was educated at King Edward's School in Birmingham, and, since he was talented at drawing, attended a Government School of Design on three evenings a week from 1848. In 1853 he went up to Exeter College, Oxford, with the intention of eventually entering the Church, and there met William Morris, who was to become his lifelong friend and an associate in a number of decorative projects.

He left Oxford and started his artistic career in 1856 under Rossetti's guidance. In the following year he inevitably found himself involved in the ill-fated project to decorate the Oxford Union with murals. Apart from these mural-paintings and some designs for stained-glass, Burne-Jones' artistic activities at this stage were confined almost exclusively to the production of minutely detailed, elaborate drawings executed in pen and ink with some wash, the highlights carefully scraped out with a knife. This technique is advocated by Ruskin in his *Elements of Drawing*, from whence the source of inspiration may have come, since Ruskin also urges his readers to study Dürer's engraving. The choice of working on a small scale seems to have been forced on Burne-Jones by indifferent health, and he only began painting in the early 1860s after his marriage.

The earliest paintings are carried out in watercolour, made dense and opaque by the addition of body-colour and ox-gall on a warm brown under-painting. This was the source of the luminosity of the Pre-Raphaelite oil-paintings painted on a wet-white ground, which had caused such difficulties in execution to the P.R.B. earlier. The two Italianate pictures of the sorceress, *Sidonia von Borke* and her cousin, *Clara von Dewitz* date from this period. Their debt to Italian Renaissance painting is obvious. The design for Sidonia's dress was taken from a portrait of Isabella d'Este by Giulio Romano at Hampton Court Palace. It is therefore appropriate that one of the greatest scholars of the Renaissance, Bernard Berenson, should have owned a version of the Sidonia portrait. The debt to Rossetti is also apparent for he was working on the similar *Lucretia Borgia* at the same date. In the same year Burne-Jones re-worked his Oxford Union subject, *Merlin and Nimuë*, and produced a number of versions of the ballad subject, *Fair Rosamund and Queen Eleanor*. This was a story which was very popular with the Pre-Raphaelites and had already been used by Rossetti and Hughes. Elizabeth Siddal had also painted a picture in 1857 (under Rossetti's guidance) which illustrates a ballad theme, called *Clerk Saunders and Maid Margaret*. This subject was probably suggested by Rossetti.

Meanwhile the firm of Morris, Marshall, Faulkner & Co. had been founded. This was a decorating business started as a result of Morris's disgust with all available materials for interior decoration and furnishing, culminating in the Red House which was built for him by Philip Webb in 1859–60. Burne-Jones was a director, with Webb and Morris, of Morris and Company, and his prolific inspiration and rapidity of execution made him of crucial value to the firm. While his painting moved inexorably away from the influence of Rossetti and the Pre-Raphaelites, his decorative work remained a continuing contribution to the evolution of Pre-Raphaelite design, which centred on Morris and his activities with the Kelmscott Press and the tapestry-weaving workshops at Hammersmith and Merton Abbey. A number of the decorative designs were turned into paintings, rather than the reverse. For example, *King Mark and La Belle Iseult* (1862) originated as a stained glass design and is in fact painted on top of a stained-glass cartoon. *Cupid Delivering Psyche* (1867) is an easel version of an illustration made for a proposed edition of Morris's *Earthly Paradise*. Burne-Jones made about seventy drawings for the project in 1865, and these easel versions also exist of *Cupid Finding Psyche*, two of them dating from 1866.

Between the Rossetti inspired works of 1861–2, and the more symbolic pictures from 1866 onwards, come the Giorgionesque *Green Summer*, the fragmentary designs for the decoration of the Red House, and *Hope*, which is still a composition in the Rossetti style and which reflects Rossetti's increasing preoccupation with the female half-lengths which dominated this period of his career.

From the mid-1860s Burne-Jones was forced to adopt a more professional approach to painting, and it is probably no coincidence that this date marks the end of his Pre-Raphaelite phase. A number of other members of the circle had already found Pre-Raphaelitism to be incompatible with a reasonably prosperous career. It is unlikely, therefore, that the precarious financial position of Madox Brown and Rossetti had an appeal as a permanent way of life.

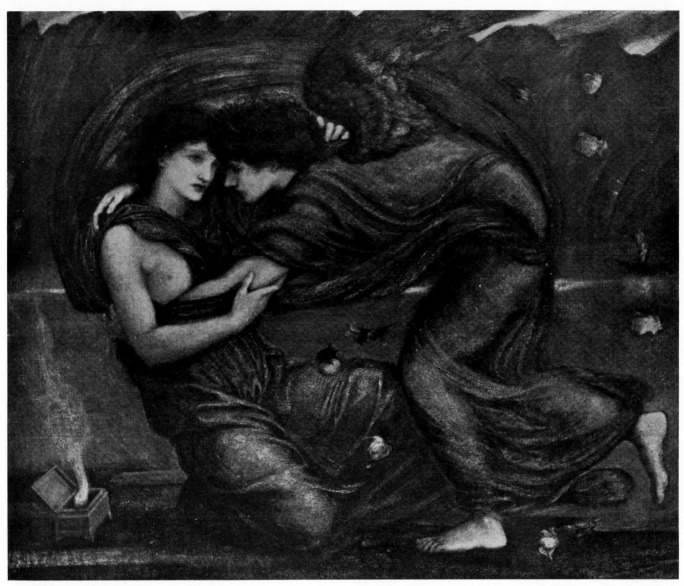

Edward Burne-Jones
Cupid Delivering Psyche, 1867. Watercolour 31½ × 36 in.
(London Borough of Hammersmith Public Libraries)

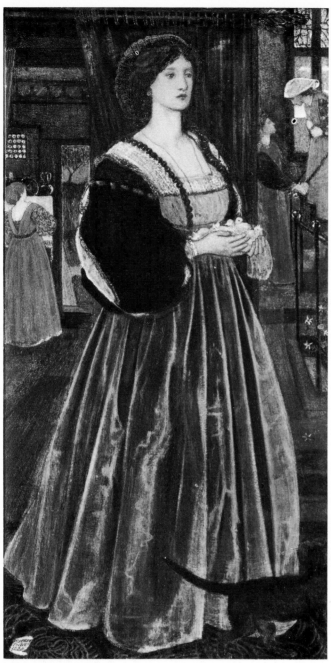

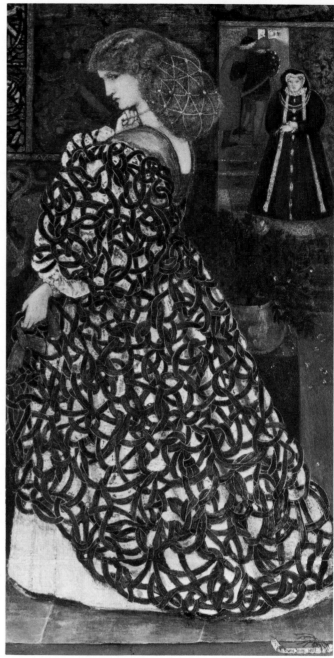

Edward Burne-Jones
Clara von Borke (1560), 1860.
Watercolour 13¼ × 7 in.
(The Tate Gallery, London)

Edward Burne-Jones
Sidonia von Borke (1560), 1860.
Watercolour 13¼ × 6¾ in.
(The Tate Gallery, London)

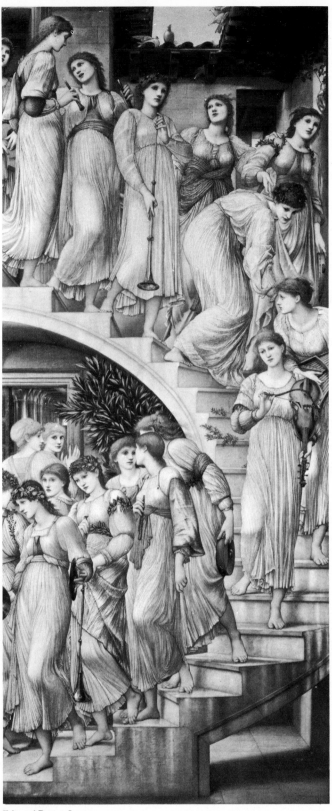

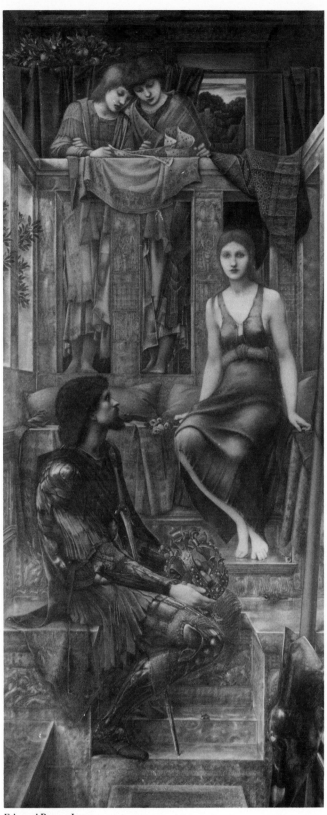

Edward Burne-Jones
The Golden Stairs, 1880.
Oil on canvas 106 × 46 in.
(The Tate Gallery, London)

Edward Burne-Jones
King Cophetua and the Beggar Maid, 1884.
Oil on canvas 115½ × 53½ in.
(The Tate Gallery, London)

Edward Burne-Jones
The Rose Bower (Panel from the Briar Rose Series), 1871–90.
Oil on canvas 49½ × 90 in.
(Photo Copyright Courtauld Institute of Art, Courtesy of the Trustees, Buscot Park, Faringdon)

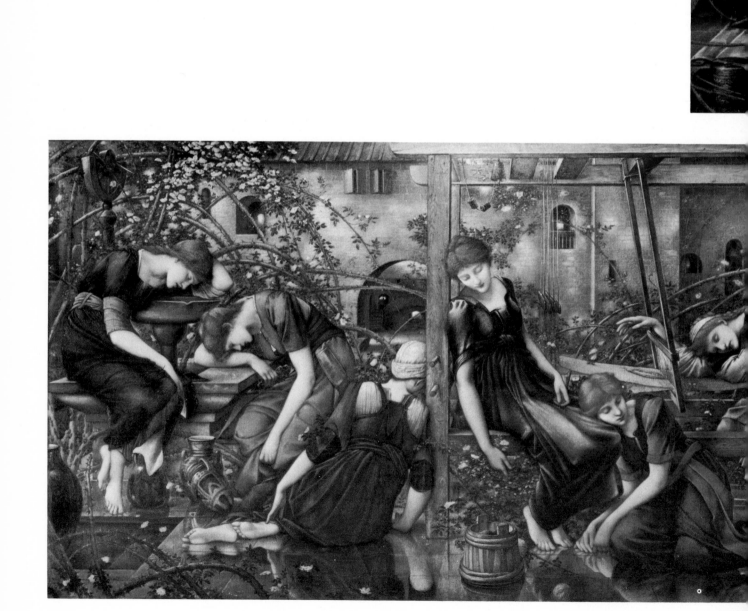